CELTIC ART
AND DESIGN

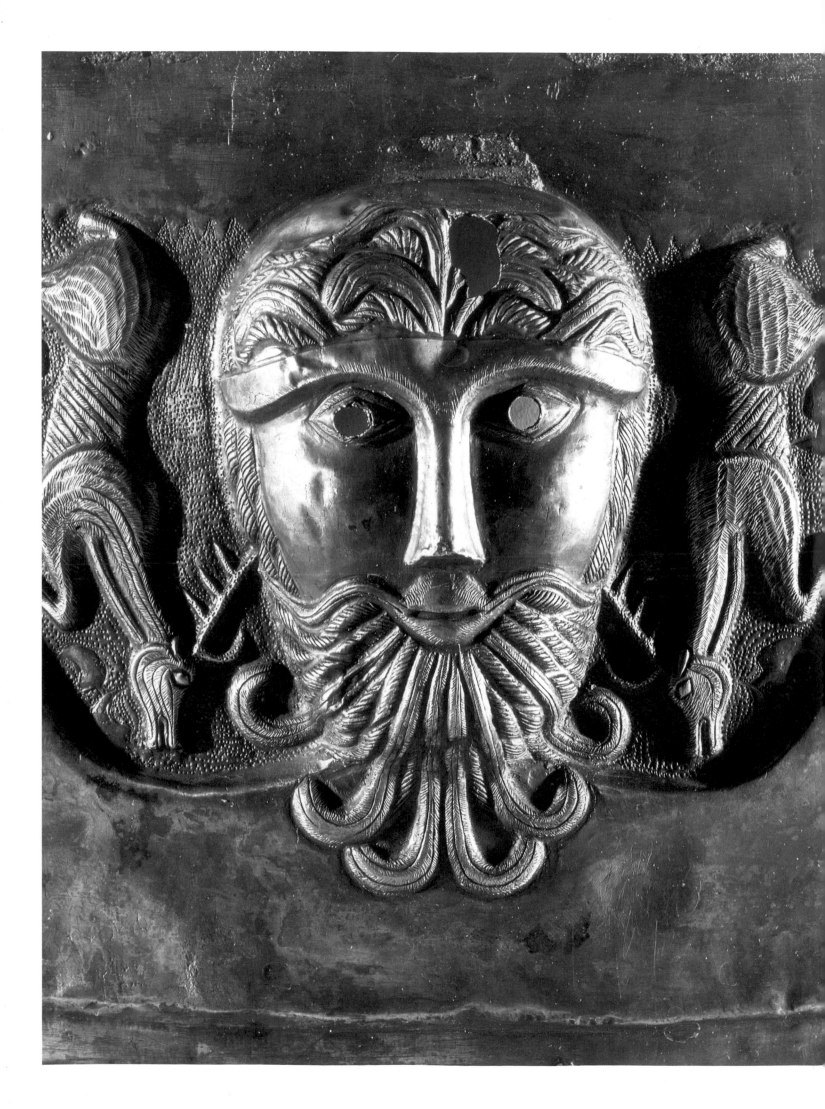

· THE TREASURY OF DECORATIVE ART ·

CELTIC ART AND DESIGN

IAIN ZACZEK

STUDIO
EDITIONS

Frontispiece:

**CELTIC DEITY FROM AN OUTER PLATE
OF THE GUNDESTRUP CAULDRON**
Silver, first century BC.

Page 6:

SILVER AND BRONZE BROOCHES
Such ornaments provided Celtic
craftsmen with an opportunity to
work on a minute scale.

500103235

This edition published 1995 by Studio Editions Ltd, Princess House,
50 Eastcastle Street, London W1N 7AP, England.

Reprinted 1995

ISBN 1 85891 191 5

Designed by SPL Design & Marketing

Printed and bound in the United Kingdom

Publisher's Note
The publishers have made every effort to locate and credit
copyright holders of material reproduced in this book
and they apologize for any omissions.

CONTENTS

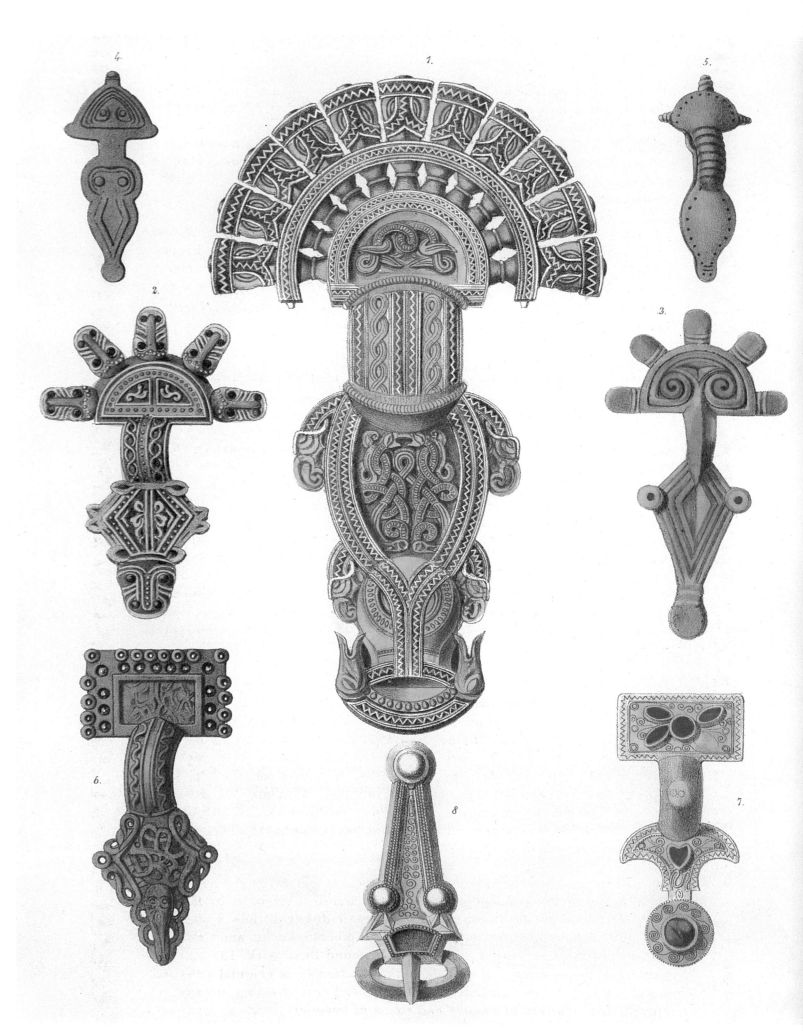

INTRODUCTION

It has taken a long time for Celtic culture to gain the accolades it deserves. For years, it was regarded as the poor relation of the classical world, its art forms denigrated as sterile, geometric and barbaric. Ultimately, however, the Celtic approach to design proved supremely resilient. It flourished for well over a thousand years, outlasting the Roman Empire which had tried so hard to suppress it and gaining a glorious new lease of life at the dawn of the Christian era.

The word 'Keltoi' was adopted by Greek writers in the sixth century BC, but certain aspects of a common culture and speech can be traced back beyond this. These Celtic peoples appear to have originated in southern Germany, Bohemia and eastern France but, eventually, they spread much further afield, occupying vast tracts of territory between the Iberian peninsula and Britain in the west and Asia Minor in the east.

The earliest recognizable forms of Celtic art have been classified as 'La Tène', so-called after an important archaeological site near Lake Neuchâtel in Switzerland. This La Tène culture has been defined as an amalgam of native European, classical and oriental trends. For the sake of convenience, it has been further subdivided into four different 'styles', although these overlap chronologically and are prey to considerable regional variations. The four categories are: 'Early Style' (emerging after c.480 BC), 'Waldalgesheim' (after c.350 BC), 'Plastic' (after c.290 BC) and 'Sword style' (after c.190 BC).

The development of Celtic art echoed the fortunes of its peoples. Thus, the inventiveness of the Early Style coincided with the period of the great Celtic expansion, and the most fruitful contacts with the classical world occurred when their armies were on the offensive (e.g. around the time of the sack of Rome in c.370 BC and the raid on Delphi in 279 BC). Conversely, the continental La Tène style began to degenerate as the Roman legions and Germanic tribes began their push westwards. At this stage, artistic change was imposed rather than created.

The reputation of Celtic art has suffered from comparisons with its classical counterpart and with the twin goals of naturalism and idealism, which have dominated art historical thinking in the West since the Renaissance. These values were little prized among the Celts. Instead, there was a marked preference for abstract, geometric patterns. Initially, these were disciplined and repetitive, often featuring imported motifs – the lyre-scroll, the lotus bud, the palmette, the tendril – but they evolved into dynamic, free-flowing designs. This decorative impulse extended to the portrayal of human and animal shapes, where sinuous stylizations took precedence over any concern to represent natural or individual features.

The greatest achievements of early Celtic art were in metalwork and stone. The smith held a special place in society. He was accorded elaborate burial rites and was allowed greater freedom to move between different tribes. There were also craft-Gods, typified by the Irish triad of Goibhniu, Luchta and Creidhne, who forged magical weapons which always found their mark. These metal-working skills were geared towards the production of ceremonial arms and armour, the trappings associated with horse- and chariot-riding, ornamental mounts for a variety of vessels and items of jewellery, such as torcs and

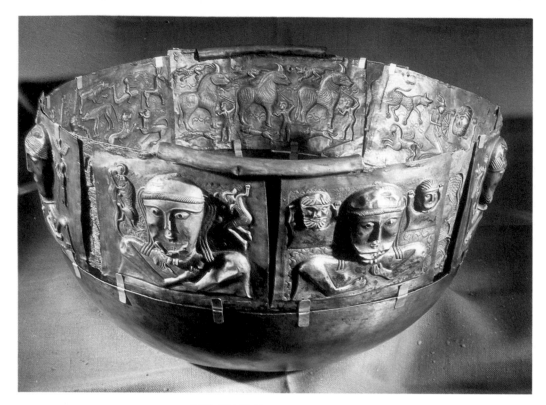

THE GUNDESTRUP CAULDRON.
Silver, first century BC.
This gilt silver cauldron consists of embossed plates welded
together, and measures about 70cm across the rim.

brooches. Sculptors, meanwhile, concentrated on the human form, creating a range of grim-faced, stylized heads that were designed to strike fear and awe into the beholder.

Our fullest appreciation of Celtic art is hampered by a dearth of written records. Ironically, it is from their enemies that we can learn most about their customs and practices. It is from classical authors that we can read of the Celtic taste for brightly emblazoned shields, of their insatiable love of gold; of how chieftains like Boudicca wore torcs as a status symbol.

Some information can be gleaned indirectly from archaeological finds. From the flagons and utensils left at burial sites, we can deduce that the Celts believed in an after-life which involved feasting, while the presence of wheels – common symbols of the sun – in some tombs indicates the existence of a solar cult. Other grave goods denote rank rather than ritual. Members of the noble class were occasionally buried in chariots or carts, along with high-status objects. Some of these , such as golden torcs and lavishly engraved mirrors, are predictable while others, like the glass beads of a game resembling ludo, are more surprising.

Much can also be learned from the votive offerings which the Celts made. Ceremonial items, like the Witham and Battersea Shields, were deliberately deposited in rivers. The latter were revered as a source of life and many owe their present names to their Celtic protective spirits (e.g. the Boyne, which derives from the goddess Boann). Bogs, too, were a focus for ritual activity. The Gundestrup Cauldron, for example, was carefully dismantled and placed on a flat, dry section of peat bog, where it would have been plainly visible. The fact that it was not removed may have something to do with the darker practices that took place in this kind of setting. Evidence of human sacrifice has been found in marshy sites at Tollund in Denmark and Lindow Moss in

Cheshire. In both cases, the victims were given a ritual meal before being garotted.

One aspect of Celtic belief which was reflected more closely in their art was an abiding interest in metamorphosis. Literary confirmation of this can be found in the dozens of Welsh and Irish legends, where gods and heroes were transformed into birds, wolves and boars. Metalworkers took delight in exploiting these ambiguities. Many designs, which appear at first glance to be abstract, can be seen on closer inspection to contain rudimentary faces. Historians have dubbed this the 'Cheshire style', in honour of Lewis Carroll's cat. Sometimes, these features can provide intriguing insights into the Celtic way of life. It has been suggested, for instance, that Celtic mirrors were hung upside down after use, as many of them (though not the Desborough example) have cats' faces on their handles, which can only be discerned if they are seen from this angle. The Celtic fascination with shape-shifting persisted into the Christian era, when it offered a creative outlet for the inventive powers of the Gospel miniaturists.

Other areas of Celtic life remain much more elusive. Their pantheon of gods, for example, is still largely obscure. Even Cernunnos, the horned deity that is associated with the greatest number of surviving artefacts, has only been firmly identified by an inscription on a single monument. Nowhere is this problem more clearly illustrated than on the Gundestrup Cauldron. This major find demonstrates beyond question that Celtic art was not purely ornamental, but the lack of comparative material has made its iconographical details tantalizingly difficult to read. Indeed, despite the wealth of literature that it has spawned, the only general point of agreement among critics is that the cauldron did not originate in Denmark. Some authorities have noted stylistic affinities with the work of Thracian silversmiths, suggesting that the vessel may have been produced in an area around present-day Romania or Bulgaria. The problem with this, of course, is in ascertaining how the cauldron made its long journey north. Other scholars have maintained that the item was assembled in Celtic Gaul, and that it may have been plundered by German mercenaries serving with Caesar's army, perhaps from one of the druid centres in the territory belonging to the Carnutes. Neither of these theories sheds a great deal of light on the iconography, however, and the principal attempts to interpret this have used the 'Táin Bó Cuailnge', an Irish epic written many centuries later, as a starting point.

Britain was at the outer fringes of La Tène culture. Signs of Celtic influence can be traced back as far as c.300 BC, when the 'Arras' people in Yorkshire performed chariot-burials comparable to those on the continent. Echoes of both the Waldalgesheim and Plastic styles have also been detected in certain native artefacts, but whether these were based directly on imports or derived from local, settled workshops is hard to determine. A truly Insular school (i.e. from Britain and Ireland) appears to have been established by the second century BC, its earliest masterpieces being a series of finely engraved swords and scabbards. At any rate, Celtic culture must have been deep-rooted by the time of the Roman invasion, as it survived the occupation and underwent a resurgence after their garrisons were abandoned. The extent to which native craftsmen were influenced by the invaders is much disputed. However, some of the carpet-pages in the Gospel books evoke memories of Roman mosaics, while the taste for decorated pins and penannular brooches appears to have blossomed during the period of occupation.

The purest Celtic tradition survived, of course, in the Irish and Pictish territories, which had always remained beyond the reach of Roman control.

This was to gain a particular significance in the following centuries, as Europe was gradually converted to Christianity.

The spreading of the gospel in this area began in the fifth century. In 431, Pope Celestine I appointed Palladius as the first bishop of Ireland, but his ministry was soon overshadowed by that of St Patrick. According to legend, it was he who challenged King Laoghaire at the sacred site of Tara and silenced the druids with his teachings. St Columba was also active in Ireland for a time, founding monasteries at Derry and Durrow, before embarking on his celebrated mission to Iona in 563. On the mainland, the two decisive expeditions were led by St Augustine (597) and St Aidan (635) who established bases at Canterbury and Lindisfarne respectively.

These missions did not owe their success to manpower alone. Vestments, relics, liturgical vessels and, above all, books were sent from Rome to aid in the conversion process. These texts were copied in the monastic scriptorium and the extra manuscripts were either returned to Rome or used in the quest to extend the Christian message still further. Insular workshops rapidly gained a reputation for the high quality of their texts and, by the late seventh century, they were playing an active role in the missions to continental Europe. The pioneers were St Wilfrid, who preached in Frisia in 678-9, and Wihtbert, who followed him there a decade later. Even greater success attended the efforts of St Willibrord, who was consecrated archbishop of Utrecht in 695 and founded the monastery of Echternach three years later. The prize possession of this new house, the so-called 'Echternach Gospels', may well have been one of the many Insular volumes which made their way from Britain to the continent. In any event, the importance of this British link in the missionary chain should not be underestimated. It has been reckoned, for example, that half of the surviving Latin Gospels from the period between 400-800 can be attributed to Insular centres.

Of course, manuscripts like the Book of Kells and the Lindisfarne Gospels were exceptional. The majority of the books produced in monasteries would have been for scholarly study or practical, everyday use. Moreover, few communities had the time or the resources to expend on such lavish and intricately decorated tomes. A letter from Abbot Cuthbert of Wearmouth to the archbishop of Mainz puts this problem in perspective. In it, the abbot apologized for the delay in sending some books, explaining that his scribes had been unable to work properly for long periods, as their hands had been numbed by the chill winter weather. Clearly, under such conditions, a scriptorium could not function with the efficiency of an assembly line.

Undoubtedly, the great Gospel books were designed as showpieces. Confirmation of this can be inferred from the inscription at the end of the Lindisfarne Gospels. This places the date of the manuscript very close to 698, when St Cuthbert's body was transferred to an impressive new shrine and pilgrims would have flocked to visit it. An ideal time to dazzle visitors with a sublime new version of the Scriptures. Certainly, the more spectacular Gospel books were treated with the same reverence as holy relics. Special shrines or 'cumdachs' were designed to house them and there was widespread belief in their talismanic properties. Bede related how scrapings from Irish manuscripts were used to treat snakebites, while popular superstition suggested that the Book of Durrow had the ability to cure sick cattle.

The visual splendour of the Gospels was due to the unique situation which existed in Ireland and Northumbria. The monastic artists were the heirs of a

long and largely undiluted Celtic tradition of craftsmanship. In their exuberantly decorated initials and their ornamental carpet-pages, they could employ the extravagant spirals, the bestial heads and the elaborate animal interlacings that had featured on pagan metalwork for centuries. This was fused with early Christian imagery, which the monks adapted from the books that were sent from Rome. In some cases, such as the portraits of the Evangelists in the Lindisfarne Gospels, the illuminators appear to have followed their models quite closely. In others, most notably in the Book of Kells, there was a true marriage between Insular and continental forms.

The Gospel books represent the tip of a considerable iceberg. The rapidly expanding Church must have required many other lavish articles for use in its services or for display in its new foundations. Many of these vanished in the Viking raids, but the surviving items confirm that the superlative standards of Celtic metalwork were maintained. The Derrynaflan and Ardagh hoards have furnished us with the finest liturgical equipment from this period, while minutely engraved crozier-heads and processional crosses date from just slightly later. A number of reliquaries have also survived. Usually, these were small, inlaid caskets, fashioned in the shape of a house. They were designed to be portable, as saintly relics were traditionally taken out of the monastery and displayed to the lay community in times of crisis. However, the design was certainly not rigid, as shrines in the form of a bell, a belt and a human arm are all still in existence. The Celtic tradition also persisted in the field of sculpture, epitomized by the elaborate high crosses that were set up in many monastic enclosures. The finest examples date from the ninth and tenth centuries and their carvings of Biblical scenes provide an interesting comparison with the Gospel miniatures.

The Norman advance into Britain and Ireland eventually engulfed the Celtic tradition, although certain aspects of its style were absorbed by Romanesque artists. Since then, there have been frequent Celtic revivals, as successive generations have shared the sense of wonder experienced by Giraldus Cambrensis, the twelfth-century historian, when he first set eyes on one of the illustrated Gospel books. Describing it as 'the very shrine of art', he urged the viewer to examine it closely. 'You will make out intricacies, so delicate and subtle, so exact and compact, so full of knots and links, with colours so fresh and vivid, that you might say that all this was the work of an angel, and not of a man.'

Iain Zaczek

PLATE 1

GOLD OPENWORK MOUNT

Schwarzenbach, fifth century BC

This magnificent piece of metalwork was uncovered in 1849, when villagers in the German village of Schwarzenbach uncovered two La Tène tombs among their orchards. Here, the principal finds included a small face, modelled out of sheet gold, and this fine openwork mount, which was originally used to cover a cup. The wooden vessel has long since disappeared, but it was undoubtedly a funerary cup, intended for feasting in the Otherworld. The Celts believed strongly in an afterlife and pre-Roman graves often contained wine flagons and spit-roasting bars. The dead were thought to reside at Otherworld 'hostels', where there were magical cauldrons with an inexhaustible supply of cooked pork.

This cup-mount displays one of the earliest phases of Celtic metalworking. Later, their smiths would endow a comparatively formal design such as this with a flowing, organic quality. The decoration of the treasury is based on palmette and lotus bud motifs, which are oriental in origin and which had probably filtered west through the medium of classical art. On the base of the mount, however, we can see the *triskele* (three-legged) motif, one of the most ubiquitous features of Celtic design.

Courtesy of the State Museum, Berlin

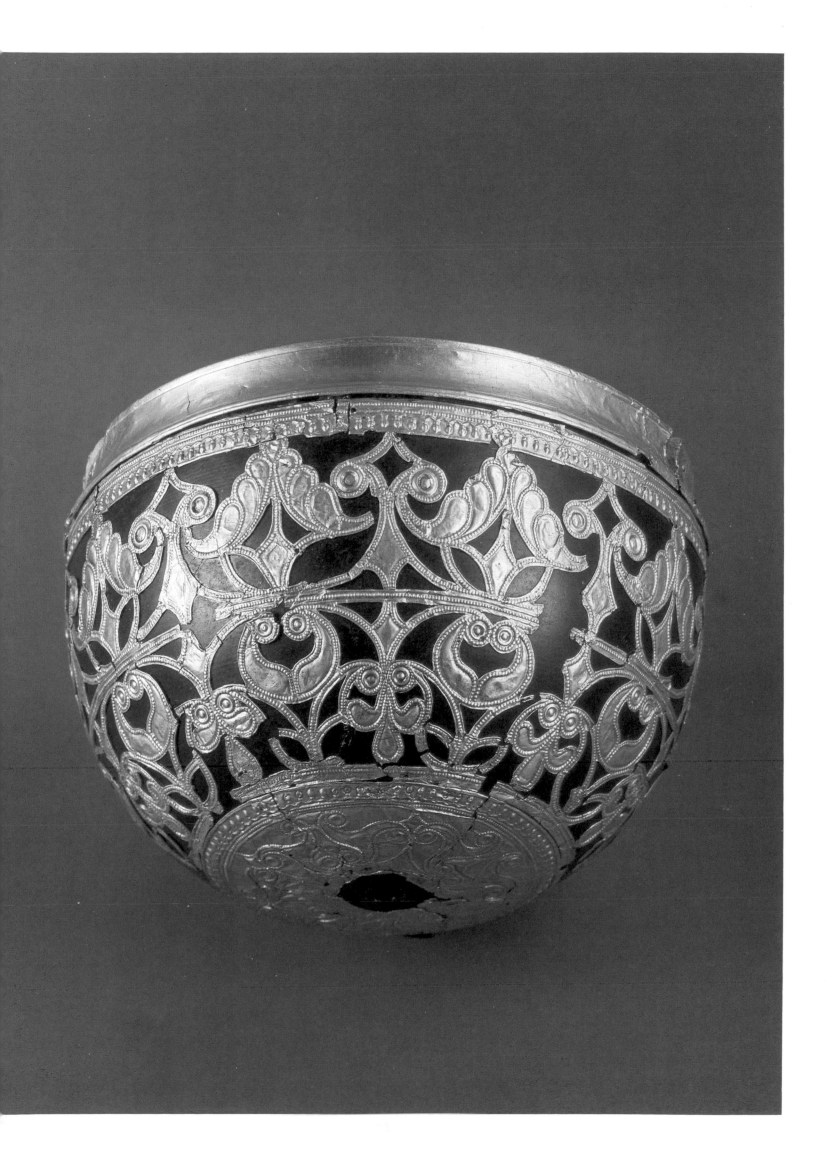

PLATE 2

THE WITHAM SHIELD

Lincolnshire, bronze, third/second century BC

In 1826, this spectacular item was dredged up from the river Witham in Lincolnshire. Like the Battersea Shield, it had probably been placed in the water intentionally, either to propitiate the local river spirits or else in gratitude for a safe crossing.

The elegant design has been hammered out in repoussé (i.e. beaten out from behind) and decorated with insets of red enamel. Stylized versions of two, long-snouted animal heads, perhaps horses, can be seen at either end of the central spine, and the outer roundels feature delicately engraved wing and fan patterns. These elements, however, were not part of the original design. Tiny rivet holes demonstrate that there used to be a cut-out of a boar attached to the front of the shield. As the illustration shows, the animal was highly stylized and had long, tapering legs. Among the Celts, the boar was a very conventional war symbol. They used to carry boar-headed trumpets into battle, terrifying their enemies with the raucous calls that emanated from the animals' jaws. On a practical note, it is possible that the hollow boss was added in the centre to allow room for a hand-grip at the back of the shield.

Horae Ferales, Kemble, Franks & Latham, 1863

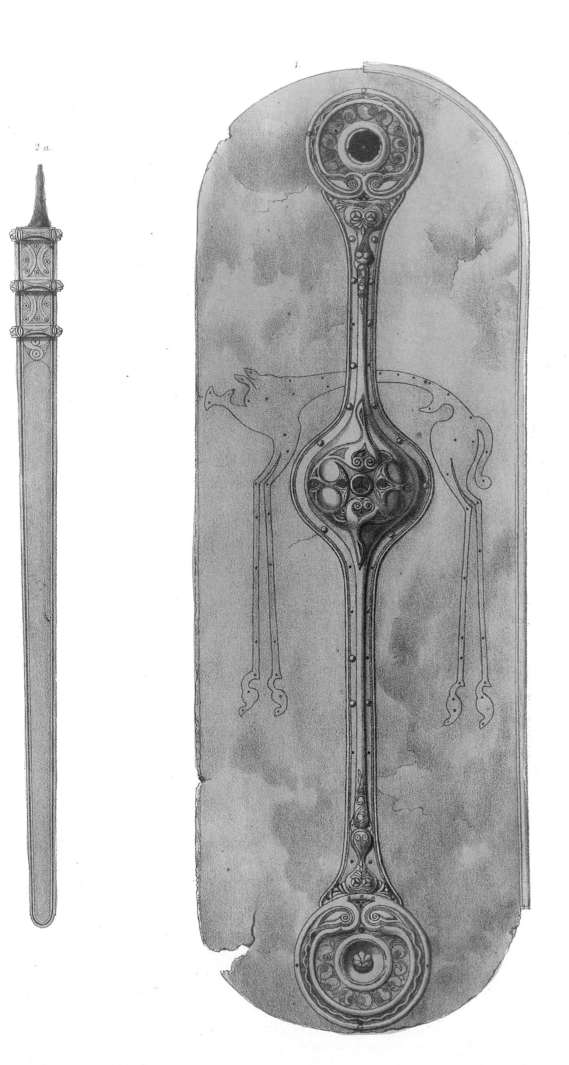

PLATE 3

THE BATTERSEA SHIELD

London, bronze, first century BC

This is one of the most celebrated examples of metalwork from Iron Age Britain. It was constructed from four pieces of bronze attached to a wooden base and would originally have been gilded. This has now vanished, but the pieces of red glass decorating the studs and the finely hatched metal swastikas still give some idea of the dazzling impression it must once have made. In true Celtic fashion, the curvilinear design appears abstract at first glance, but hints of figuration can soon be detected. The spirals connecting the three roundels, for example, have been interpreted as bulls or oxen with extravagantly curved horns.

Magnificent though it is, the shield would not have been sturdy enough for use in battle, and the luxurious design confirms that its true purpose was ceremonial. The fact that it was recovered from the Thames also suggests that it was used as a votive offering, to placate local deities. Similar items have been retrieved from the river - most notably a horned helmet at Waterloo Bridge.

Estimates of the shield's age vary considerably, ranging from the third century BC to the first century AD. Supporters of the later date have argued that the symmetrical design indicates a Roman influence.

Courtesy of the British Museum, London

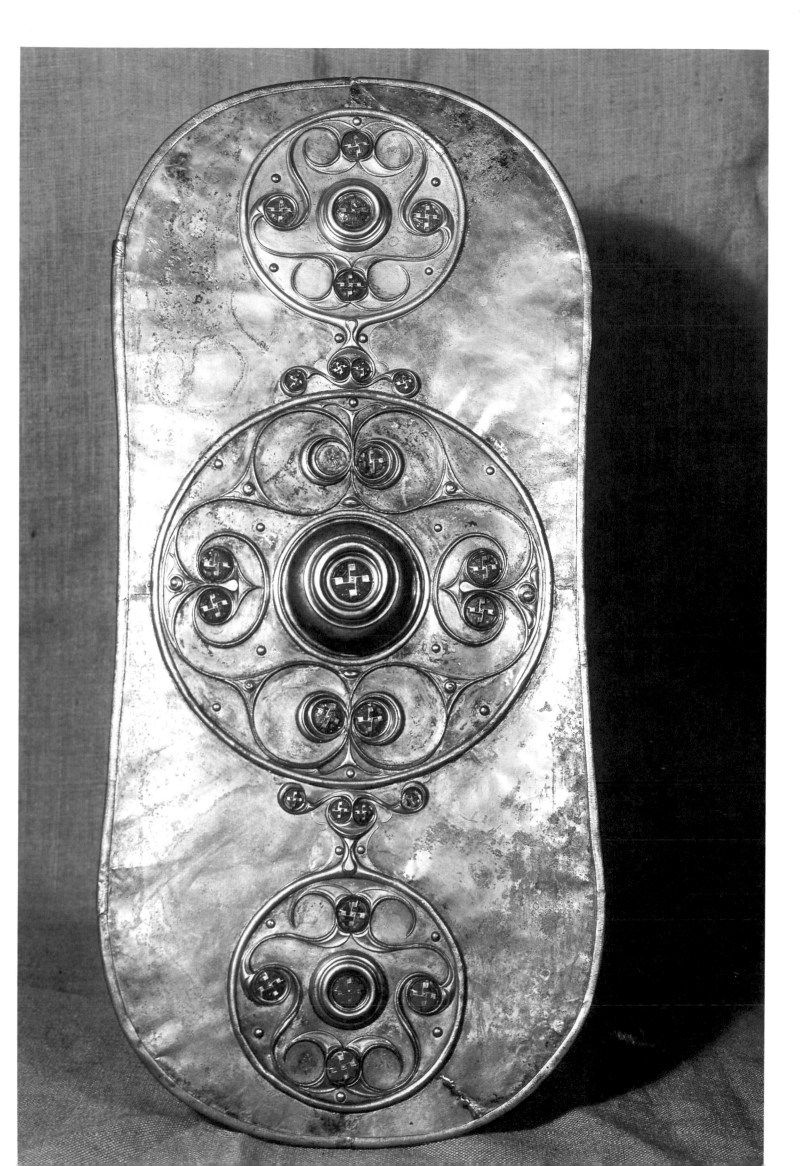

PLATE 4

SILVER DISC

Villa Vecchia, Manerbio sul Mella, Italy, first century BC

This disc is part of a find that was made at a grave in Cenomani territory. It is a phalera, which a soldier might wear on his chest as a form of military decoration, or which could be added to the trappings of his horse. The two largest discs in the collection featured a *triskele* (three-legged) device on the central boss, but this one is plain. However, it remains interesting as an illustration of the way that Celtic artists depicted heads. These rarely showed any signs of individuality and were notable for their bulging, vacant eyes, puffed-out cheeks and downturned mouths.

The severed head was a potent image for the Celts, often appearing as decoration on metalwork and carvings. This may have been due to their head-hunting practices, which were described at length by classical authors. Celtic warriors often decapitated their foes, fastening the heads to their saddles or preserving them for use as cult vessels. Alternatively, they became ritual trophies in shrines like Entremont, where human skulls were nailed into niches, next to sculptures of severed heads.

Courtesy of the Archaeological Museum, Brescia

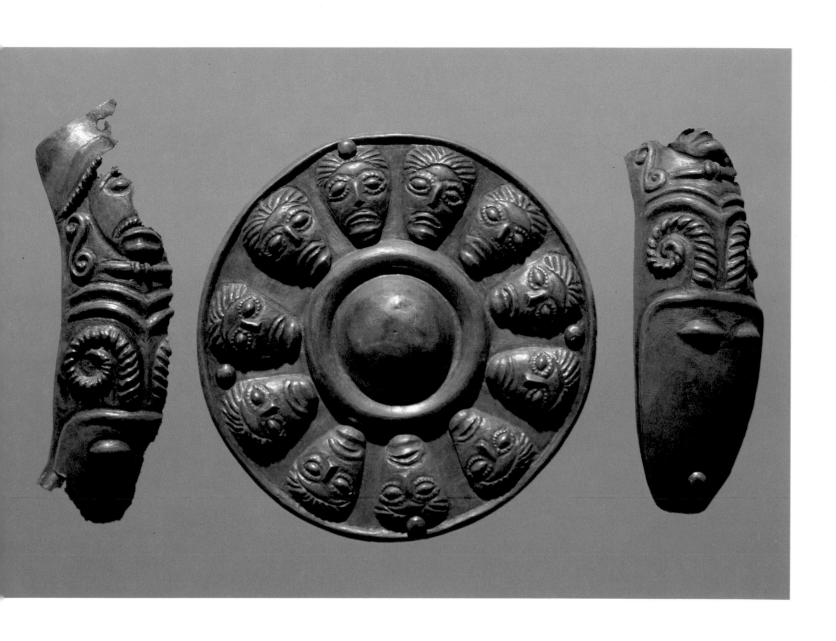

PLATE 5

CELTIC GODDESS - OUTER PLATE OF THE GUNDESTRUP CAULDRON

Silver, first century BC

Originally, there were eight plates on the outside of the Gundestrup Cauldron and seven of these have survived. Each of them is dominated by the large, mask-like face of a god or goddess. These were beaten out of a sheet of silver and tiny pieces of glass were inserted into the vacant pupils. On one of the plates, these 'eyes' are still in place.

None of the iconography on the cauldron can be interpreted with certainty and, by and large, the imagery of the outer plates is less clear than those of the inner ones. However, the presence of three birds in this scene may allude to one of the war goddesses, such as Morrigán, Medb or Badbh. All of these had the power to shape-shift into ravens or crows, usually communicating with soldiers under this guise. As scavenging birds, they had obvious associations with war and death, so it is hardly surprising that Morrigán was habitually described as the 'battle crow'. The prone figures of the dog and the human by the goddess's breasts may be a further allusion to this, or they may suggest a reference to the Otherworld. If so, the deity may be a figure like Rhiannon. The songs of her three magical birds were supposed to be so enticing that they could wake the dead in their graves, while lulling the living to sleep.

Courtesy of the National Museum, Copenhagen

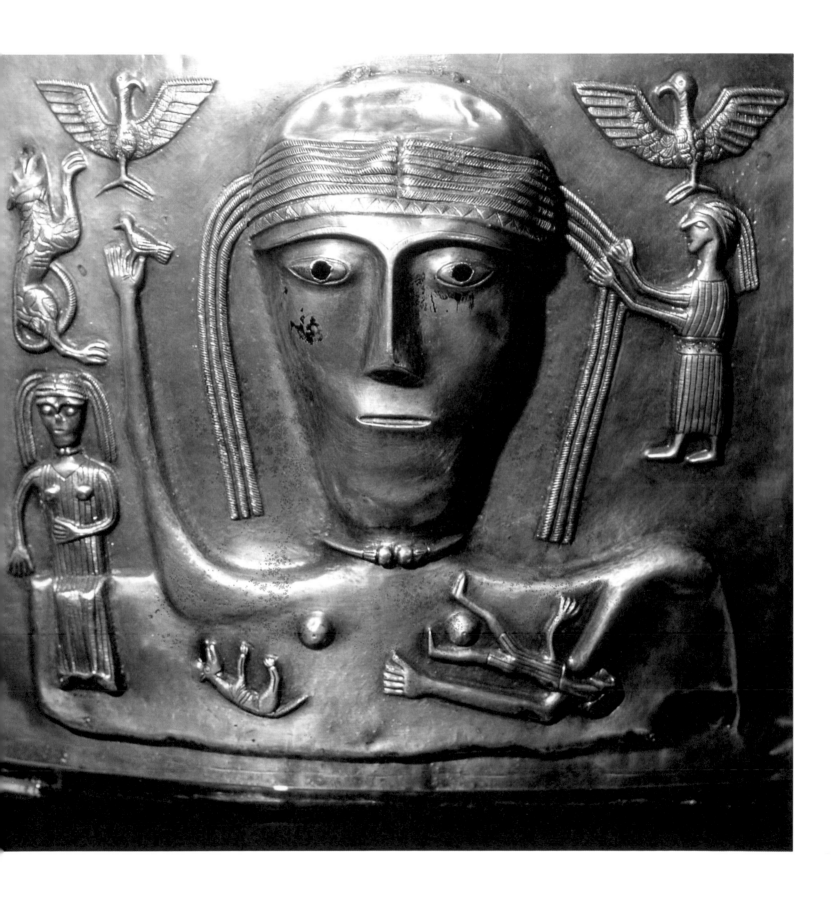

PLATE 6

INNER PLATE OF THE GUNDESTRUP CAULDRON

Silver, first century BC

This is one of the most celebrated sections of the Gundestrup Cauldron. A Celtic deity sits cross-legged, wearing antlers and a torc. He holds a second torc in his right hand and a ram-horned snake in the other. A stag and a wolf flank him and pay great attention to his actions. Around them, other animals are disporting themselves, including a lion, a deer and a boy riding a dolphin.

This god is usually identified as Cernunnos, largely on the strength of a similar image on a Gallo-Roman altar from Rheims. There, too, the horned deity squats cross-legged, emptying a sack of grain or coins before a stag and a bull. Cernunnos was a god of nature, fertility and plenty, and this is confirmed by his attributes. The ram-horned snake was a common Celtic motif, combining the fertility symbolism of the ram with the sense of renewal that was implicit in the snake's ability to shed and replace its skin. The torc, as a highly regarded status object, could easily be seen as a token of abundance, roughly equivalent to the classical cornucopia. The theme of fertility is further emphasized by the low-relief tendril pattern which spreads throughout this entire plate.

Courtesy of the National Museum, Copenhagen

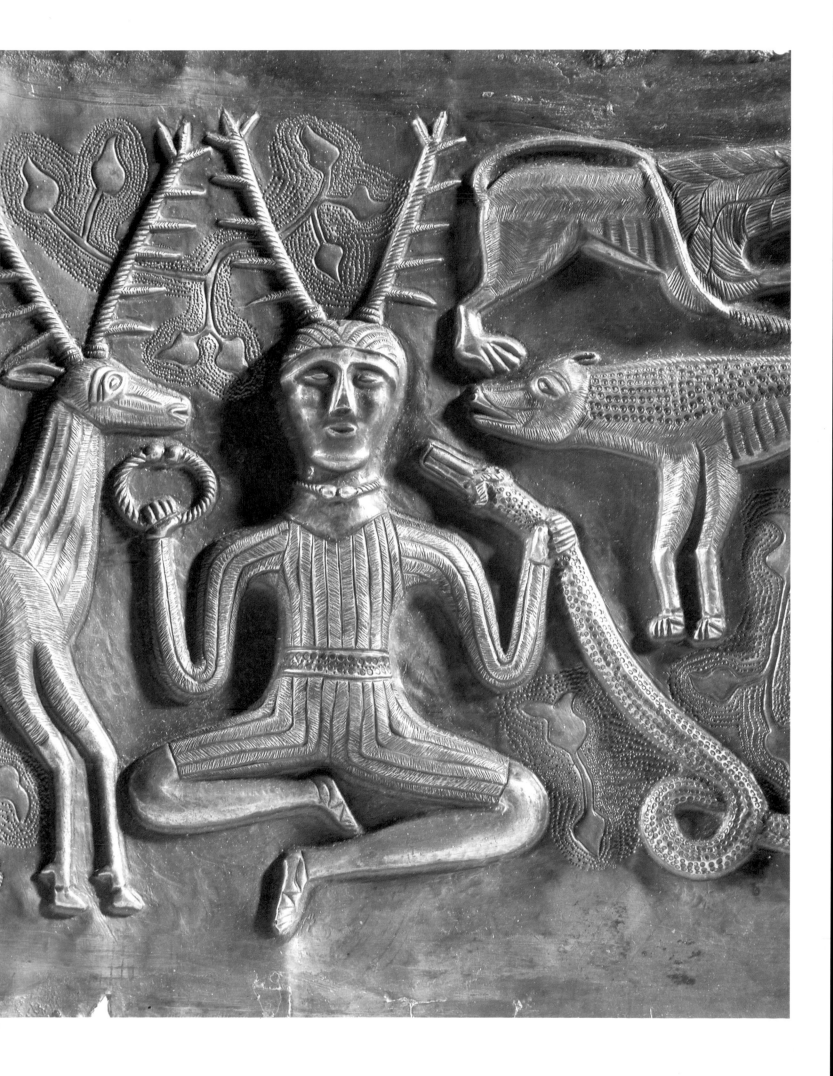

PLATE 7

INNER PLATE OF THE GUNDESTRUP CAULDRON

Silver, first century BC

Attempts have been made to interpret this enigmatic scene by comparing it to an episode from the Irish epic, the 'Táin Bó Cuailnge' ('the Cattle Raid of Cooley'). According to this theory, the smaller figure gripping the wheel is Cú Chulainn, the hero of the epic. He is shown attacking the bearded giant, Ferghus mac Róich, using a broken chariot as a weapon. In an earlier confrontation, Cú Chulainn had faced the shape-shifting war goddess Morrigán, who had fought him as a wolf, a hornless red heifer and an eel. Cú Chulainn had defeated her in this final guise, by cracking her ribs with his toes, and it may be that this incident is reflected in the way that the warrior is leaping over a ram-horned snake. The 'Táin Bó Cuailnge' is part of the Ulster Cycle and, in its written form, it postdates the Gundestrup Cauldron by many centuries. However, the epic stems from a long oral tradition and the theory is that it may represent the Irish version of an ancient myth that was well known throughout many of the Celtic territories. Without this analogy, the scene is virtually unreadable. The wheel was a widespread solar symbol among the Celts and featured frequently in their burial rites, but its meaning in this context is unclear.

Courtesy of the National Museum, Copenhagen

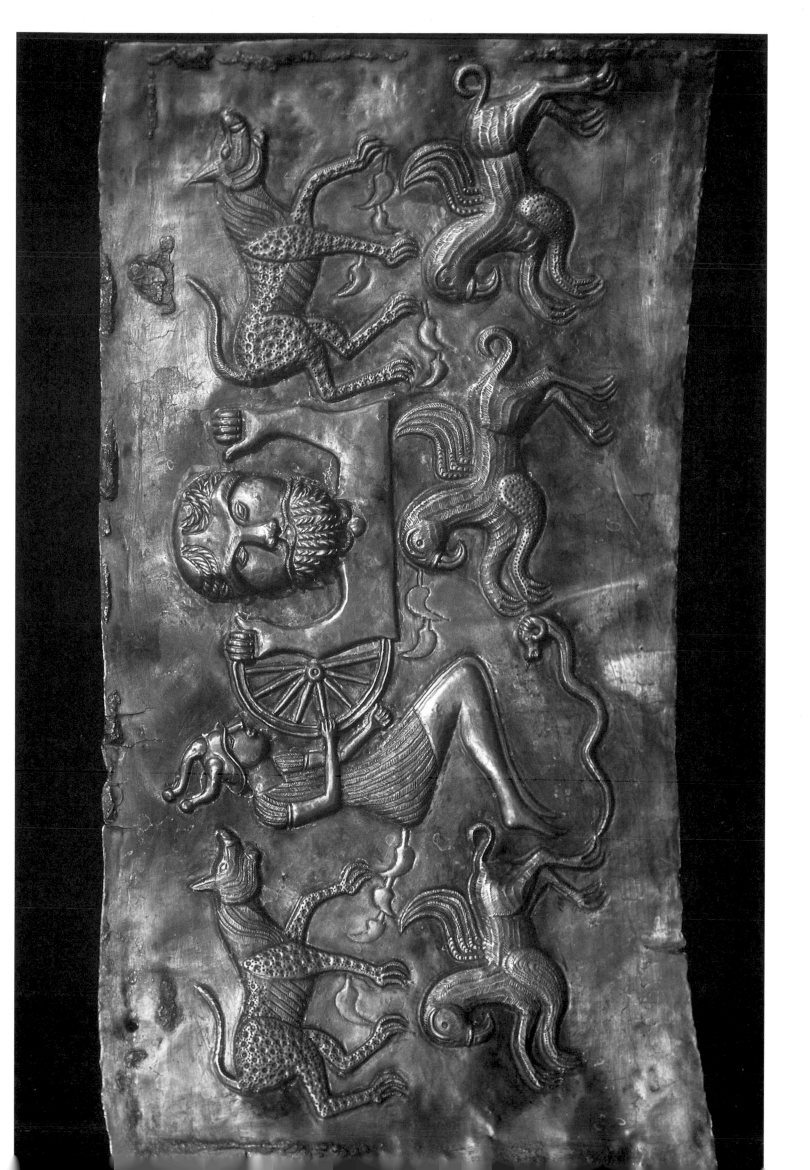

PLATE 8

MIRROR FROM DESBOROUGH

Northamptonshire, bronze, late first century BC

The Celts acquired their taste for richly decorated mirrors from the classical world, where they were prized, in particular, by the Etruscans. By the time of the Roman occupation, the fashion had spread to Britain and some three dozen mirrors have been discovered in southern England, which appear to date from the second half of the first century BC or the early years of the first century AD.

The general format of these mirrors - their traditional kidney shape and their engraved backs - followed classical models, but their style of decoration was quite distinctive. The ornamental effect was achieved by the contrast between the smooth, polished bronze and the 'basketry' patterns engraved with the use of a tracer. Most of the designs were tripartite, built up from a basic structure of three linked circles. However, the Desborough mirror, which was found near a hillfort in 1908, is one of the most sophisticated examples. Here, the pattern has evolved into two reversed lyre-scrolls, linking a series of smaller spheres. At the outer edges of the design, there are two small triangles within circles. These may have been added as a symbol of good luck or, less probably, as a craftsman's mark.

Courtesy of the British Museum, London

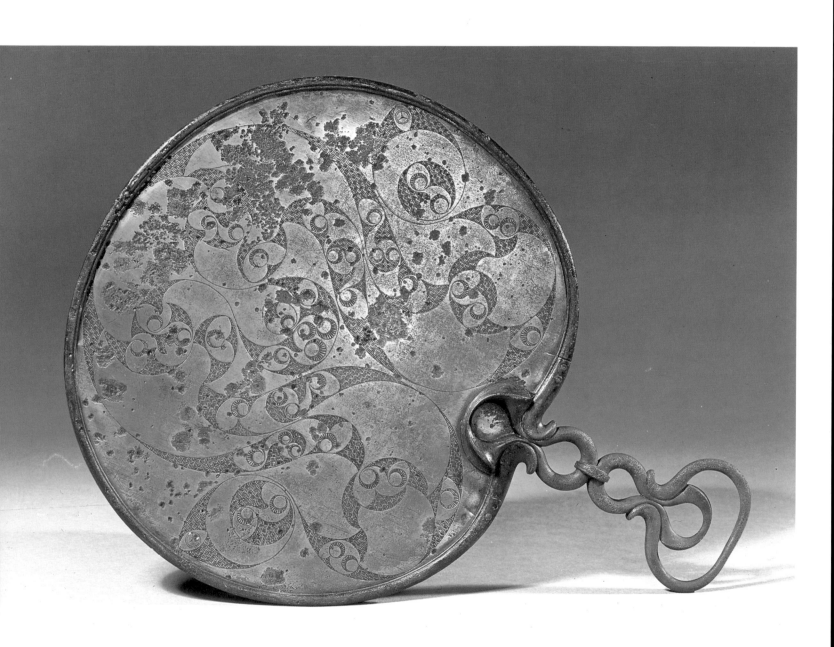

PLATE 9

BRONZE HARNESS MOUNTS

Polden Hills, Somerset, first century AD

Horses played a major part in early Celtic society, so it is not surprising that archaeologists have unearthed a wide variety of objects associated with riding and chariots. Along with harness fittings like these, the finds include bits, terrets (chariot rings, through which the reins were passed) and, most impressive of all, a bronze pony-cap with relief modelling. The items illustrated here come from the Polden Hills' hoard, which was discovered during ploughing in 1803, and they are particularly notable for their use of the champlevé technique of enamelling. This involved cutting away a pattern in the metal and inlaying it with coloured enamel. The latter was applied in powdered form and fused into place when the metal was heated. Red was the preferred colour, but yellow, green and blue were also available. The mounts contain several of the motifs most favoured by Celtic smiths — lyre-scrolls, trumpets, commas and peltas (shield-shaped ornaments) — along with a hint of their taste for zoomorphic decoration. Note, for example, how the semicircular side-pieces of one of the mounts display the so-called 'Cheshire cat' faces, which only take on shape if viewed from the correct angle.

Horae Ferales, Kemble, Frank & Latham, 1863

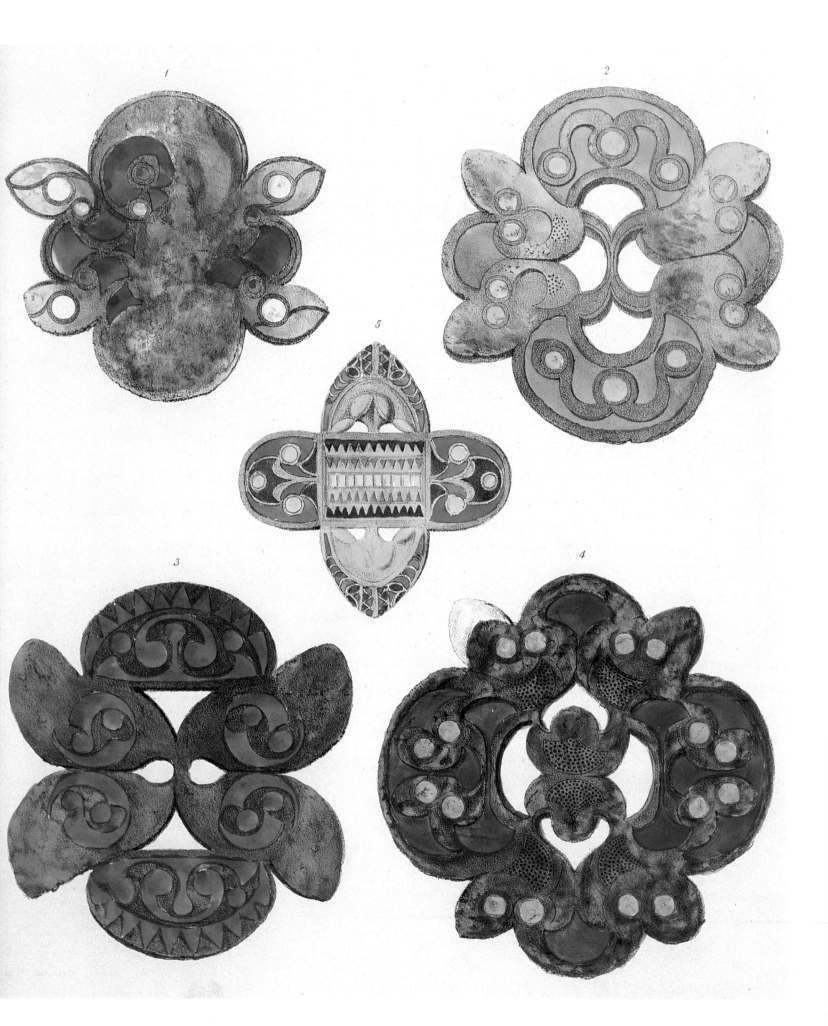

PLATE 10

CARPET-PAGE

Book of Durrow, f.192v, *c.*675

The Durrow Gospels constitute one of the earliest masterpieces of Insular book production. A later inscription in the volume suggests that it was based on a manuscript once owned by St Columba (*c.*521-597) and the monastery at Durrow was one of his foundations. Opinion is sharply divided over where the book was made — its Irish credentials have been challenged by both Lindisfarne and Iona. However, the manuscript was certainly in Ireland by the early tenth century, when King Flann (d.916) commissioned a 'cumdach' (shrine) for it. A century later, it was at Durrow itself, some fifty miles west of Dublin. The tiny dimensions of the volume, just 9 x 5 inches, would have made it easy to transport between these various locations.

The most glorious features of the Book of Durrow are its carpet-pages, all of them notable for their elaborate interlacing. Six of the original seven survive and, as this would have been the sixth in the series, it has been suggested that there is a reference here to the sixth day of Creation. Thus, so the argument goes, the stylized snakes and quadrupeds echo the arrival of the 'cattle after their kind, and every thing that creepeth upon the earth' (Genesis 1:25). Note the button-like cross in the centre, so often the focal point of a carpet-page design.

Courtesy of Trinity College Library, Dublin

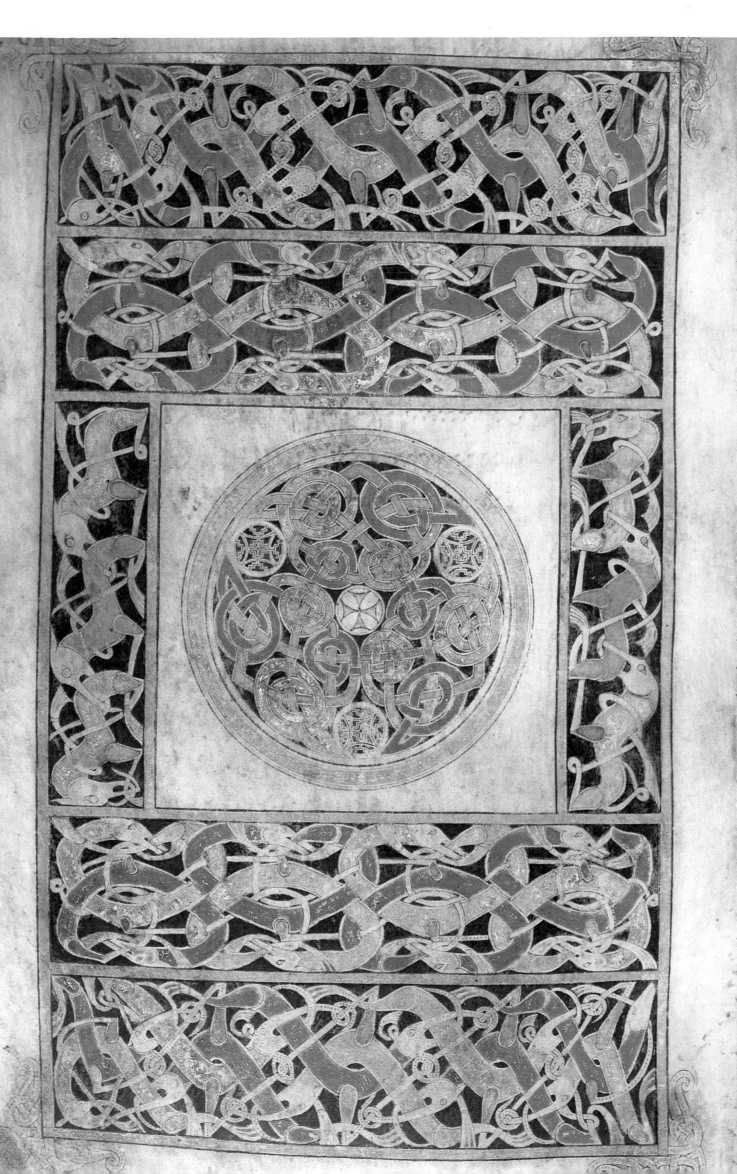

PLATE 11

PORTRAIT OF ST MARK

Lindisfarne Gospels, f.93v, *c*.698

The portraits in the Lindisfarne Gospels have been the subject of much discussion. Many stylistic elements point to a classical source - the sharply drawn facial features, the crisp curls of St Mark's hair and the linear folds of his garments. The Latinized Greek of the title ('O Agius Marcus') suggests a Byzantine provenance and this theory is strengthened by the similarity of the portrait to a group of ivory carvings on the life of St Mark, which were probably executed in either Constantinople or Alexandria. Curiously, Mark is shown wearing a 'chlamys', fastened at the shoulder with an oval brooch. This form of dress was normally worn by distinguished laymen and it may indicate that this image was modelled on a portrait of a civilian author. The presence of classical manuscripts in the Lindisfarne scriptorium is not surprising, as many were sent there for copying.

Mark is accompanied by his traditional attribute, the lion, which grasps the Gospel between its paws. The evangelical symbols derived ultimately from the Four Beasts of the Apocalypse, as described in the Book of Revelation (Rev. 4:7) and in Ezekiel's prophecy (Ezek. 1:10).

Courtesy of the British Library, London

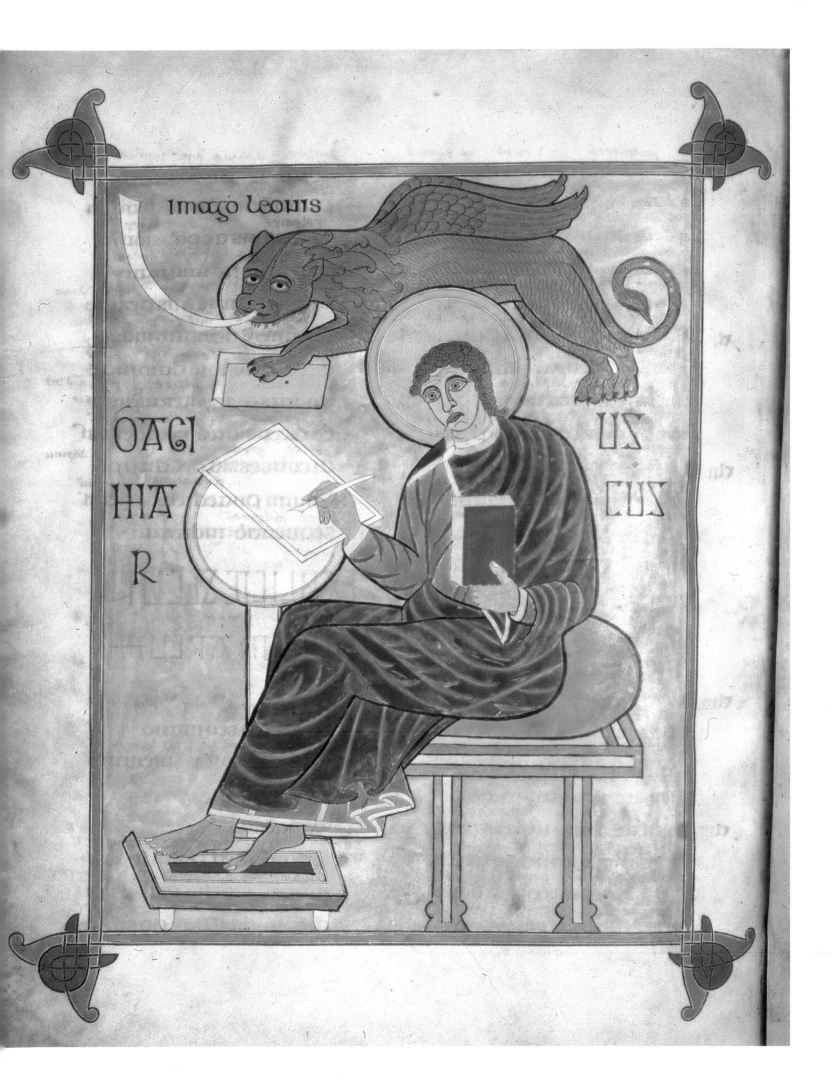

PLATE 12

PORTRAIT OF ST MATTHEW

Lindisfarne Gospels, f.25v, *c.*698

This complex portrait shows St Matthew ('O Agius Mattheus') seated on a bench, working at his Gospel. The pose of the saint is very close to that of Ezra in the 'Codex Amiatinus', an Insular version of a manuscript from the library of Cassiodorus, which was then undergoing production at the nearby monastery of Jarrow. The cool precision of his features, however, appears to reflect a Byzantine source (see caption to St Mark). As in the other portraits, the Lindisfarne artist experienced considerable difficulty in conveying the placement of the feet and the formation of the sandals. Above the Evangelist is his symbol, a winged figure with the face of a man ('imago hominis'). His trumpet proclaims the importance of the word.

The presence of the third character is more mystifying and has been the source of much controversy. The most likely explanation is that this is Christ, revealing the message of the Scriptures to His disciple. His book is held in a covered hand, emphasizing its sanctity. The image of the curtain may derive from the notion that Christ removed the veil from (i.e. clarified) the teachings of the Old Testament (2 Corinthians 3:12-17).

Courtesy of the British Library, London

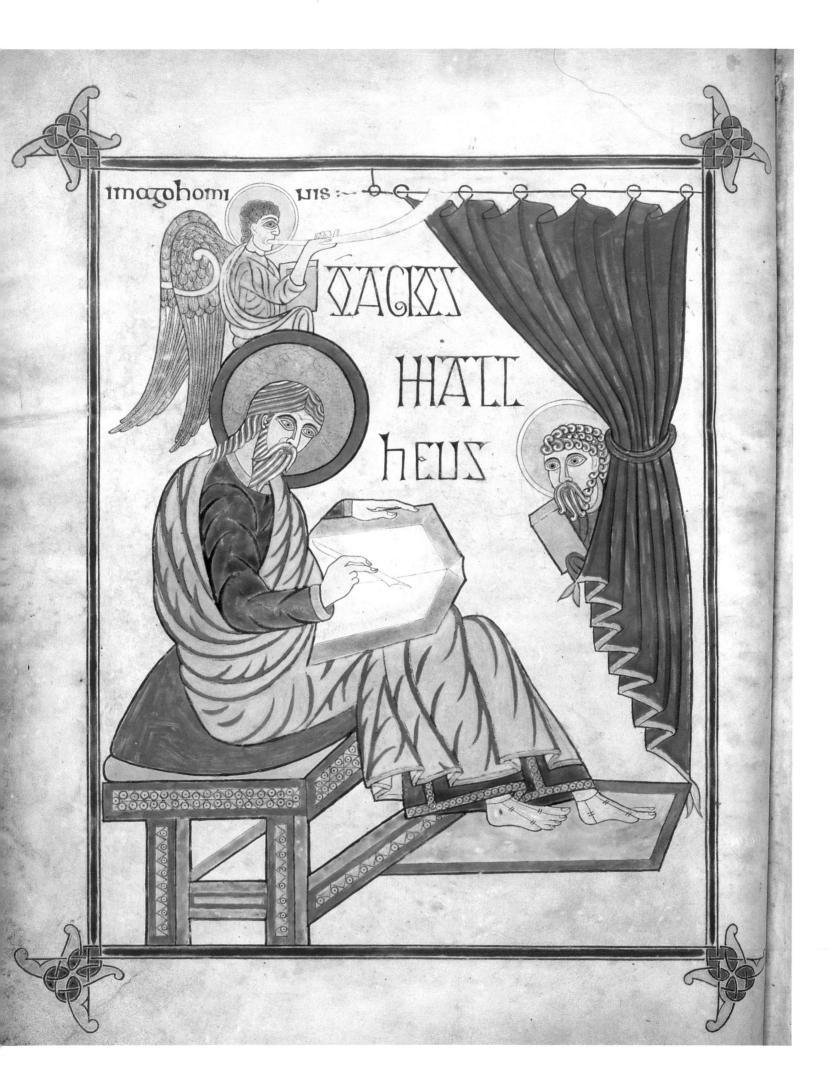

PLATE 13

CROSS CARPET-PAGE

Lindisfarne Gospels, f.26v, *c.698*

While the portraits in the Lindisfarne Gospels may exhibit a classical flavour, there is no doubting the Celtic nature of this design. Against a mesh of tightly packed animal interlacing, the outline of a cross with vase-shaped arms stands out majestically.

There are five cross-pages in the Lindisfarne manuscript; one at the start of the book and the other four at the beginning of the Gospels. In each case, there was a precise format, as the portrait of the saint was followed by a spread containing a cross-page and the initial letter of text. Thus, this design was found on the verso of folio 26, after the portrait of St Matthew on f.25v and facing the sumptuously decorated opening of the Gospel on f.27.

The carpet-pages in the Lindisfarne Gospels are often compared with the geometric designs to be found on mosaic floors, but that is less true of this particular page. Here, the closest parallels are with the stone carvings on some grave slabs or the intricate, filigree patterns of Celtic metalwork. One commentator has also likened the image to the ornately engraved metal plaques that were attached to some books, ingeniously suggesting that the small circles in the cross represent the rivets which held this covering in place.

Courtesy of the British Library, London

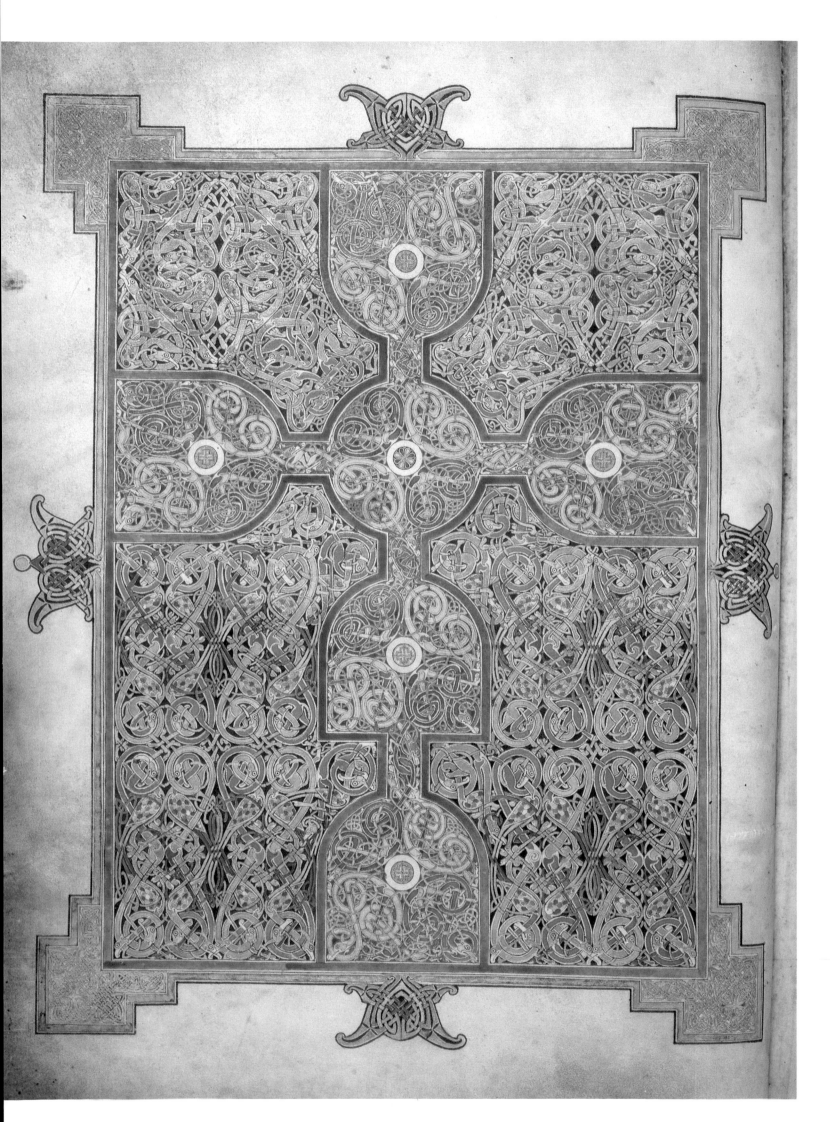

PLATE 14

BEGINNING OF ST LUKE'S GOSPEL

Lindisfarne Gospels, f.l39, *c.*698

These are the opening words of St Luke's Gospel, 'Quoniam quidem...' ('Forasmuch as many...'). As was customary in early manuscripts, the initial letter is particularly imposing. After this, the characters gradually diminish in size. As time went on, these decorative tendencies increased. On the same page in the Book of Kells, for example, the artist only found room to illustrate the very first word.

There was a practical reason for this arrangement. The current system of dividing the Bible into chapters dates only from the thirteenth century and the verses from 1551. Before this, clerics were confronted with a single, continuous narrative and the decorated pages were invaluable in helping them find their way around the unwieldy text. To modern eyes, of course, it is these apparently functionless elements that give the most pleasure. There can be few better examples of the playful nature of the Celtic imagination than the upper and right-hand borders. Here, we can see the stylized body of a cat which has just devoured eight birds. Note, also, the two birds' heads which project from the initial 'Q'. These resemble the tiny finials on the Tara brooch, emphasizing the close links between different branches of the Celtic arts.

Courtesy of the British Library, London

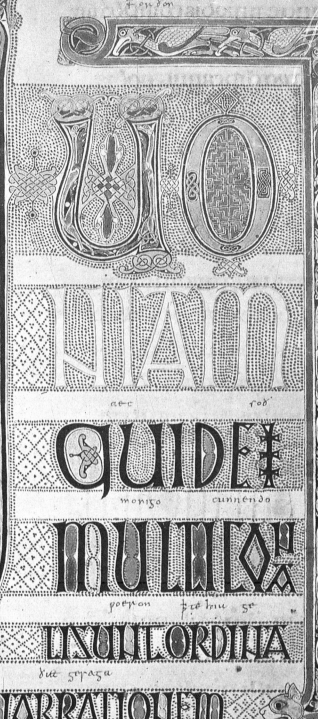

QUO
NIAM
QUIDE
MULTI
INSUNTORDINA
RENARRATIONEM

PLATE 15

THE TARA BROOCH

Bettystown, Co. Meath, gilt bronze, eighth century

Despite its name, this celebrated item of jewellery was not discovered at Tara. It was actually found in a wooden box on the beach near Bettystown. The popular name probably owes more to the reputation of Tara itself, which had been a sacred site since the Neolithic era and which was regarded as the royal seat of kings. Certainly, there is something very regal and splendid about this miniature masterpiece. Even though the hoop is just 3 inches in diameter, the quality of the engraving and filigree work is remarkable. This standard is maintained on both sides of the brooch, in spite of the fact that only the owner could truly have appreciated the beauty of the reverse side.

The 'Tara' mimicked the appearance of the penannular brooches (i.e. brooches with a gap in the hoop) that had been popular since pre-Roman times. In fact, its ring was actually closed and it had to be attached to garments by its free-swivelling pin. The decoration on the front was composed of finely engraved panels, studded with pieces of amber, polychrome glass and granules of gold. Beaded and twisted wires were soldered into place on the foil to form elaborate spiral and zoomorphic patterns, and projecting bird-heads and fish-tails were added to the edge of the hoop. These features have often been compared to the paintings in the Lindisfarne Gospels.

Courtesy of the National Museum of Ireland, Dublin

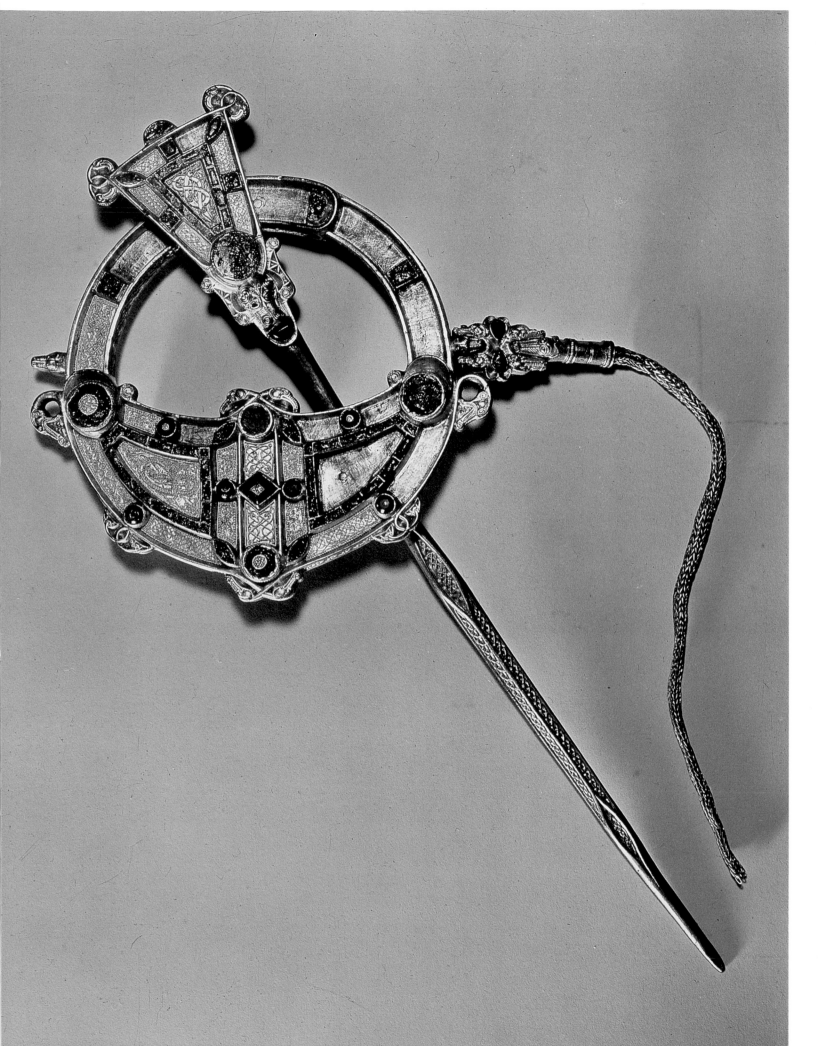

PLATE 16

THE ARDAGH CHALICE

Ardagh, Co. Limerick, silver with gold filigree, eighth century

The Ardagh hoard, consisting of two chalices and four penannular brooches, was discovered in 1868 by a young boy digging for potatoes. The larger of the chalices is one of the finest pieces of ornamental metalwork to have survived from this period and the richness of its decoration has drawn comparisons with the Tara brooch.

The chalice was formed by inverting two silver bowls and connecting them with a sturdy bronze stem. A mesh of gold filigree was used to mask this join and further filigree work can be found on the two circular bands, near the upper rim and on the base of the stem. Four large plaques adorn the sides of the chalice. All these areas of gold are punctuated with large polychrome studs. These have the appearance of enamel, but are in fact made of coloured glass cast in clay moulds. Underneath the upper circular band, the names of the Apostles have been lightly engraved. Their names appear in different grammatical cases, which has led to the suggestion that the engraver was illiterate. A large, polished rock crystal has been set in the underside of the chalice.

Courtesy of the National Museum of Ireland, Dublin

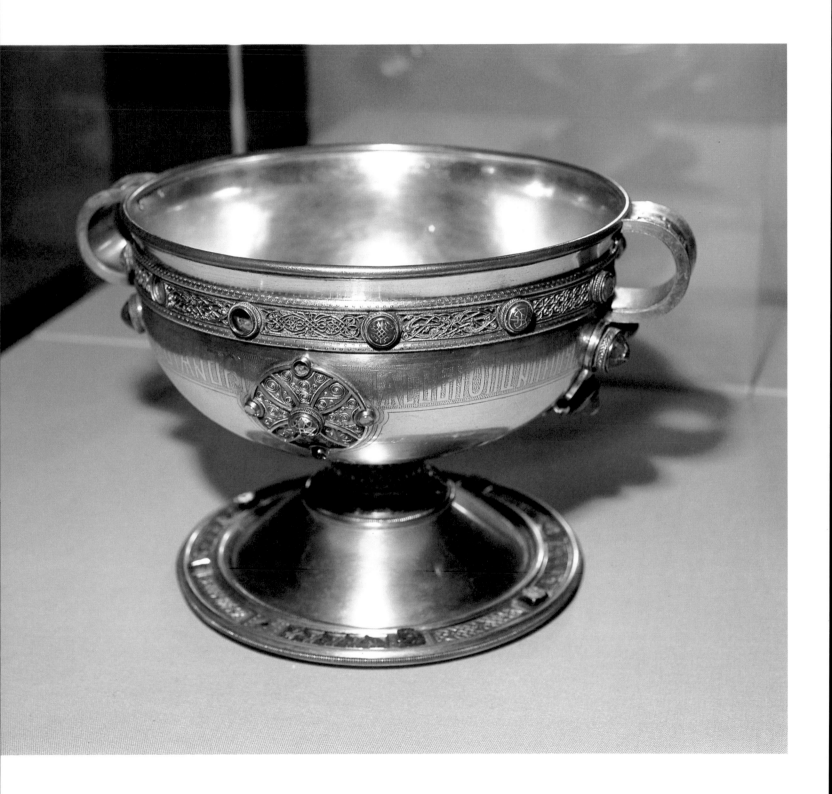

PLATE 17

THE ARREST OF CHRIST

Book of Kells, f.114, *c*.800

Scenes depicting episodes from Christ's life are unusual in the early Gospels and this is certainly the most striking example. Pinioned between two guards, His upraised arms and staring eyes evoke a mixture of horror and pity. Behind, the swirling tendrils represent the Garden of Gethsemane, while the text in the tympanum is from Matthew 26:30 ('And when they had sung an hymn, they went out into the Mount of Olives'.). The snarling animals at the top of the arch add to the air of menace. Stylistically, though, these confronted heads were a common device in Celtic art, often featuring at the ends of torcs.

The Arrest of Christ was occasionally portrayed on Celtic crosses, but it seems a surprising choice of subject in this context. The illustration does not accompany the relevant passage in the text. Instead, it follows the account of the Last Supper, which would have been the obvious theme to depict. The explanation, perhaps, may lie in the dangers which monastic communities faced at this time. Viking raids loomed large and the image of physical intimidation directed against God's chosen ones must have seemed only too familiar.

Courtesy of Trinity College Library, Dublin

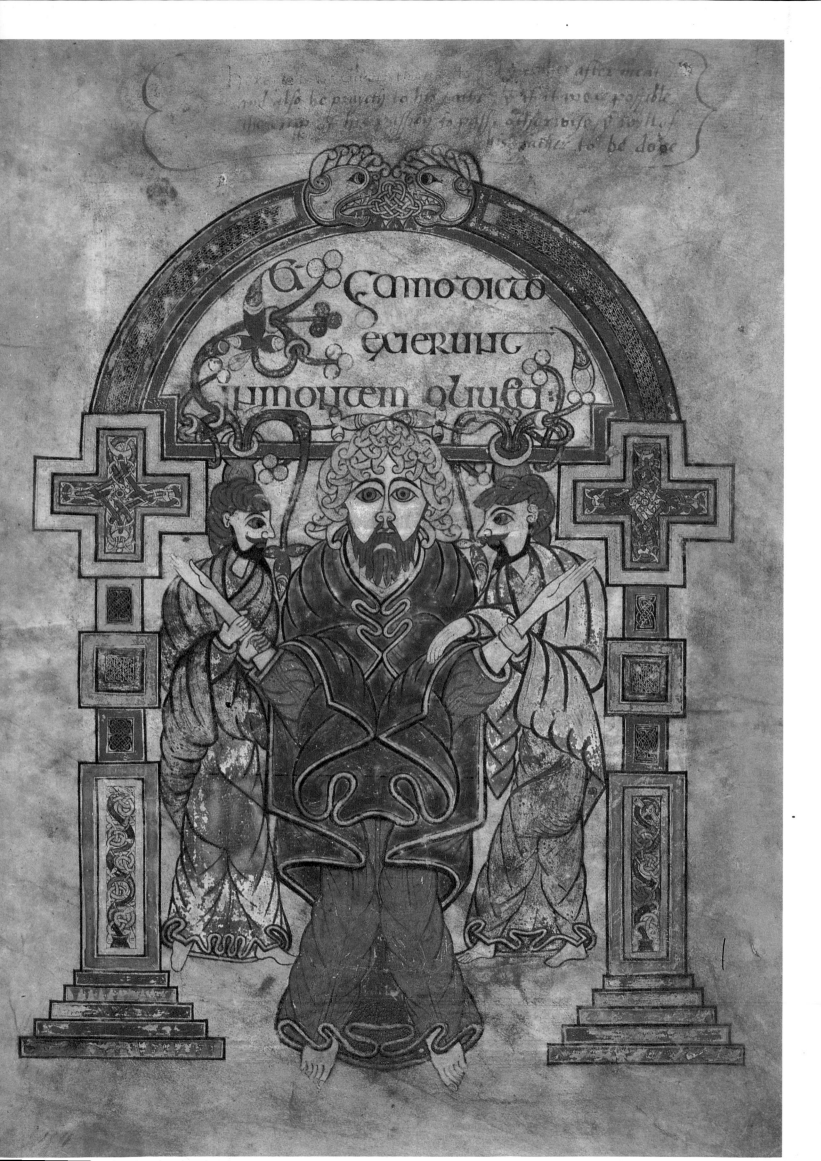

PLATE 18

THE DOUBTFUL PORTRAIT

Book of Kells, f.32v, *c*.800

The portraits in the Book of Kells have presented art historians with a number of problems. The manuscript, as we know it, is incomplete and only three of the portrait pages have survived. Two of these are normally assumed to be representations of St Matthew and St John, largely on the strength of their position in the text. The third is in a broadly similar format and may well be one of the remaining Evangelists, Mark or Luke. If so, however, it is out of place and this, combined with certain iconographical factors, has led some commentators to read it as a portrait of Christ. Unlike the Lindisfarne Gospels, none of the portraits include titles or the traditional Evangelists' symbols to assist with identification.

The Gospel of St Matthew begins with a genealogy, showing Christ's descent from Abraham. This portrait appears at the culmination of that list, just as Christ's name is mentioned. In addition, the peacocks in the tympanum are conventional symbols of immortality and the Resurrection, owing to the belief that their flesh was incorruptible. Beneath them, the chalices with vines represent the sacrament, as referred to at the Last Supper (Matthew 26:29). The likelihood, then, is that this is a portrait of Christ, although the evidence is inconclusive.

Courtesy of Trinity College Library, Dublin

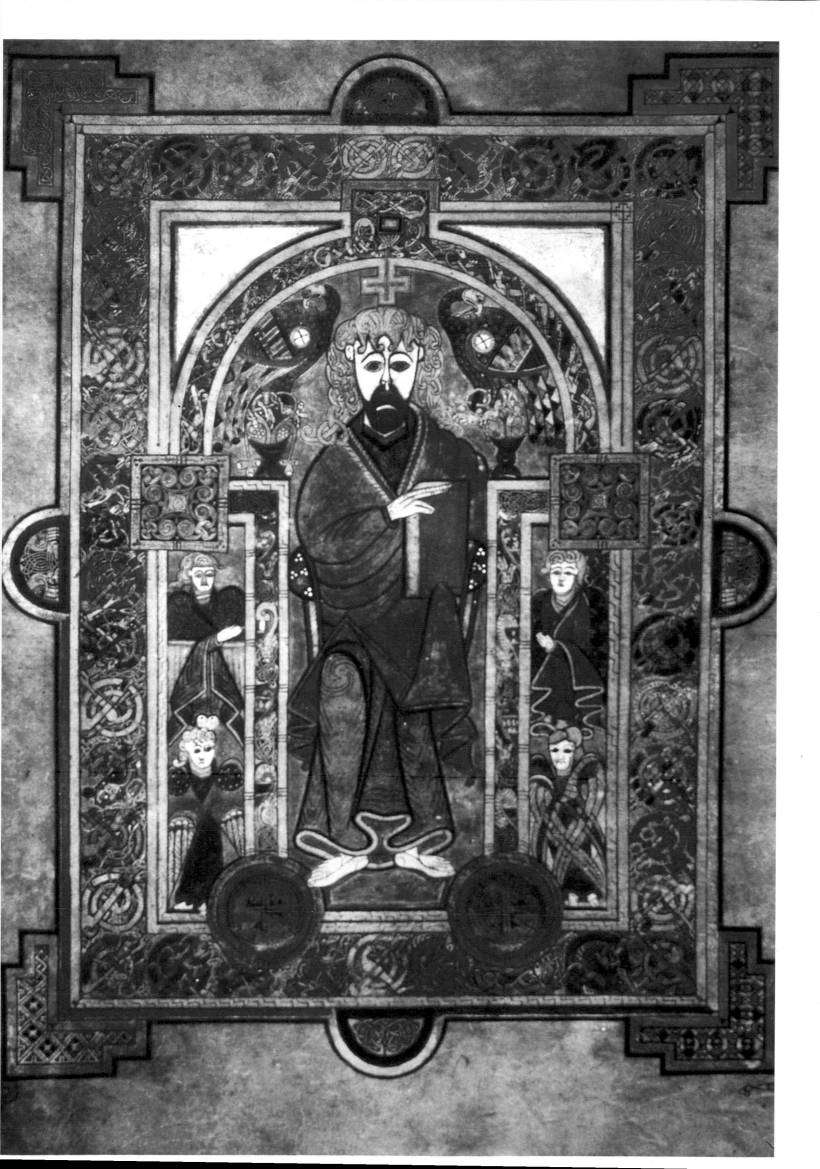

PLATE 19

CANON-TABLE

Book of Kells, f.2v, *c*.800

At the time when the Book of Kells was compiled, the Gospels were reproduced as unbroken runs of text. So, in order to make this more manageable, scholars prefaced them with a wealth of explanatory material - breves causae (chapter headings), argumenta (summaries) and canon-tables, which were designed to indicate parallel passages in the four Gospels. The system had been devised in *c*.320 by Eusebius, a bishop of Caesarea, and this, the second of the ten Canons, dealt with the material that was common to Matthew, Mark and Luke. However, the cross-references in the tables are far from complete, confirming that the Book of Kells was intended for display rather than normal, everyday use.

Considering the uninspiring nature of his material, the artist has produced a most attractive design. In the tympanum, we find two of the Evangelists' symbols — the man of St Matthew and the lion of St Mark — together with a third figure which combines the head of St Luke's calf with the body of St John's eagle. Above, a personification of the Trinity grips the tongues of two snarling beasts, which are reminiscent of those in 'the Arrest of Christ' (q.v.).

Courtesy of Trinity College Library, Dublin

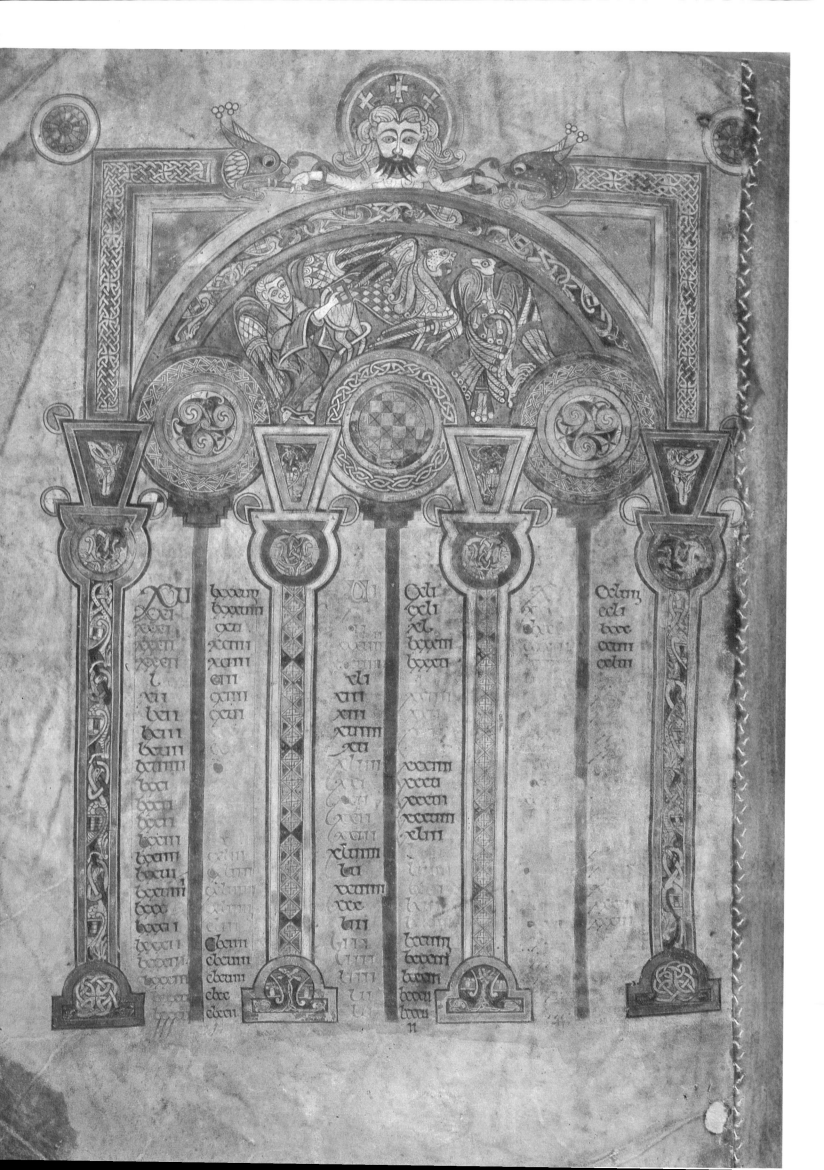

PLATE 20

THE TEMPTATION OF CHRIST

Book of Kells, f.202v, *c*.800

This page appears near the start of St Luke's Gospel and illustrates the third temptation of Christ. For this, the devil lifted the Saviour to the roof of the Temple in Jerusalem and challenged Him to prove His divinity by leaping off, saying that God would send angels to prevent Him from falling (Luke 4:9-12). Indeed, two angels hover above the figure of Christ, apparently poised for just this eventuality.

The Temptation was a comparatively uncommon subject in early Christian art and this version has several enigmatic features. The story was normally treated in a more literal fashion, with a full-length Christ standing on a roof. Here, He appears more symbolic, perhaps personifying the Church. The Temple is not based on a real building, but is strongly reminiscent of the house-shaped shrines which the Celts produced (e.g. the Monymusk reliquary). The pose of the figure in the doorway, holding two flowering rods which symbolize the Resurrection, resembles that of 'Christ the Judge'. The latter appeared in depictions of 'the Last Judgment', which was featured frequently on Celtic crosses. Interestingly enough, there is just such a figure on the Tower cross at Kells, which was carved at approximately the same period. 'Last Judgments' often included opposing ranks of the Elect and the Damned, reflecting the confrontation between good and evil, and the artist may have had this in mind when he added the crowd at the bottom. Alternatively, they may refer back to the second temptation, when Christ was offered dominion over all the peoples of the world.

Courtesy of Trinity College Library, Dublin

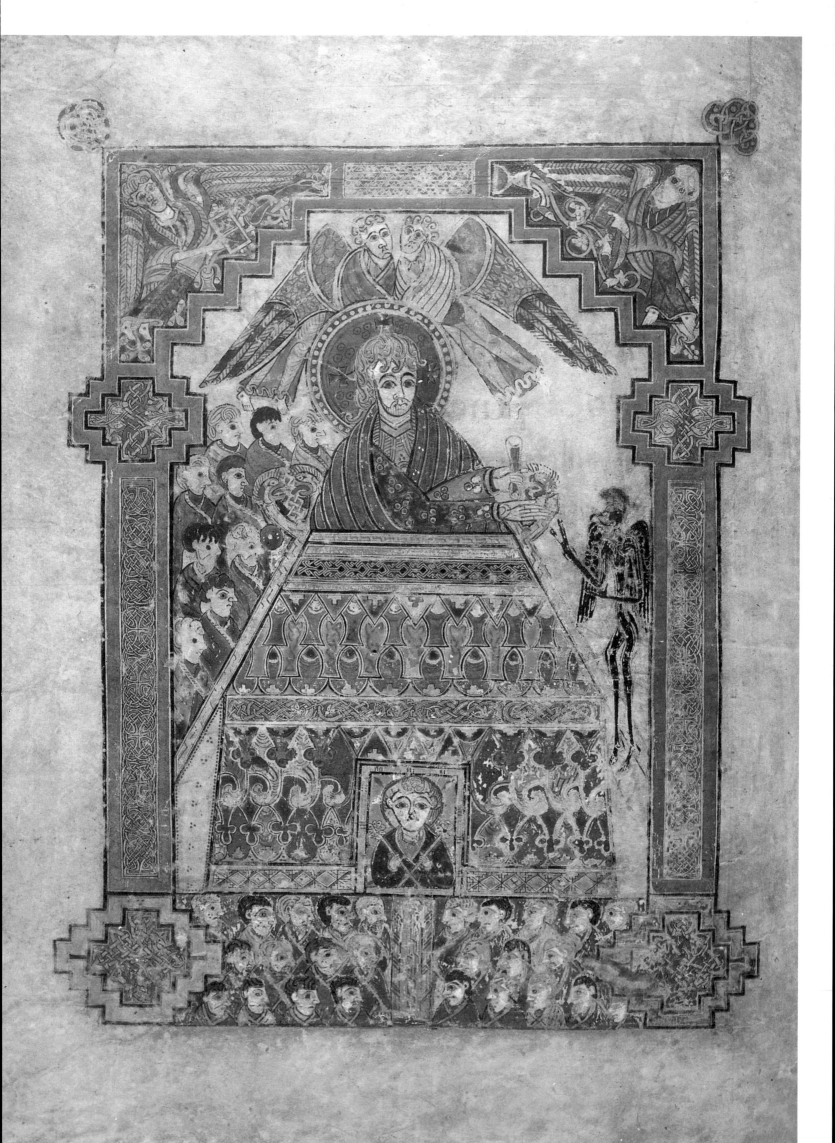

PLATE 21

THE MONOGRAM PAGE

Book of Kells, f.34, *c*.800

Most commentators agree that this is the most sumptuous piece of decoration in the Book of Kells. It illustrates the passage near the start of St Matthew's Gospel, which describes the incarnation of Christ. This section was always given special prominence by early illustrators, often receiving more lavish treatment than the start of the Gospels themselves. In this instance, the fanfare begins with the so-called 'Doubtful Portrait' on 32v (q.v.), which may be a portrait of Christ. That is succeeded by a carpet-page (f.33) — the only one in the Book of Kells — and then this dazzling display of virtuosity. Among the miniature delights are two cats watching some mice nibble the Eucharist wafer (at the foot of the 'X') and an otter with a fish in its mouth (under the 'P').

The brief text illustrated here is an abbreviated version of 'Christi autem generatio' ('Now the birth of Jesus Christ' — Matthew 1:18). The 'XP' is Christ's monogram. It is also known as the chi-rho, as these are the first two letters of Christ's name in Greek.

Courtesy of Trinity College Library, Dublin

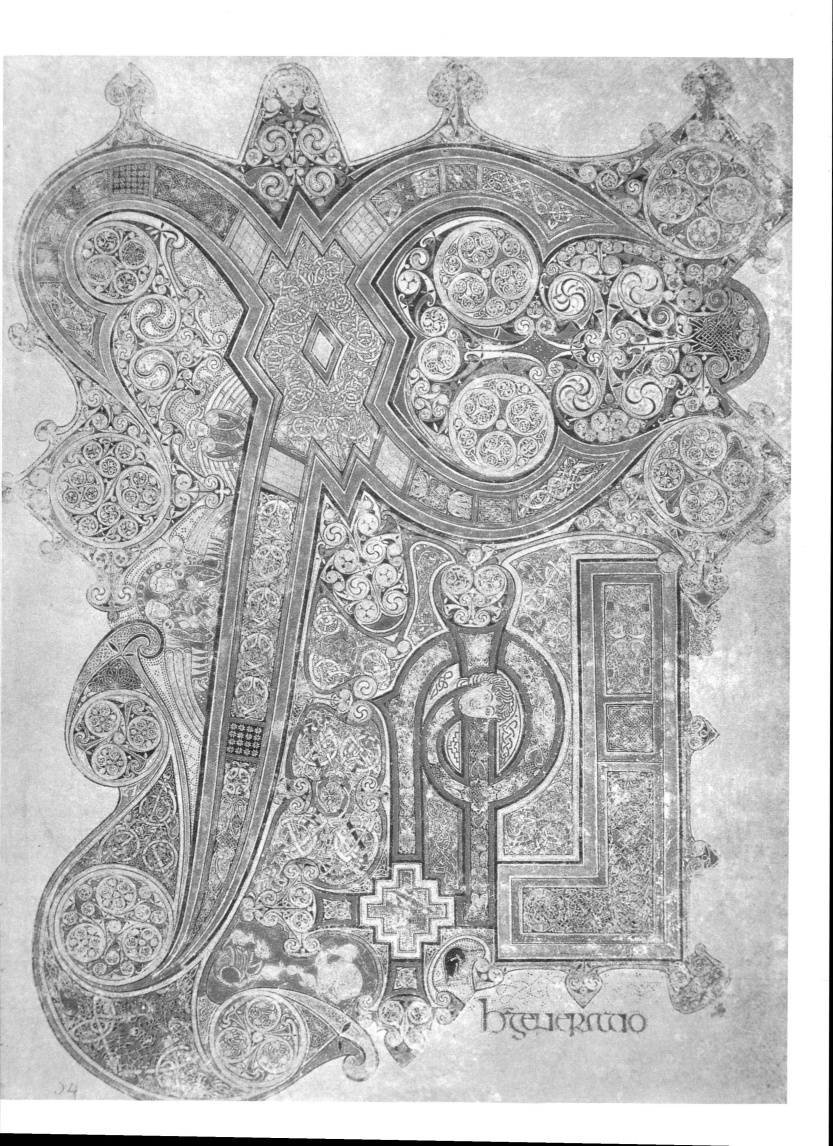

bgeueramo

PLATE 22

VIRGIN AND CHILD

Book of Kells, f.7v, *c*.800

The Madonna and Child is one of the most familiar themes in European art and this example was created to illustrate the Nativity section of the Bible story. Christ is not shown as an infant but has a mature face, emphasizing the Virgin's role as 'the otokos' ('god-bearing') rather than her purely maternal aspect. The disparity in the scale of the figures is entirely conventional — size was a convenient way of denoting importance — but the image has a distinctly eastern flavour, resembling an early icon. There is considerable speculation about the kind of manuscript that might have influenced the artist. The curious sideways pose of the Virgin, for example, has given rise to the theory that the central motif may derive from an 'Adoration of the Magi'. Certainly, there is some suggestion of borrowing. Note, for example, the apparently meaningless upward gestures of the top pair of angels - gestures that would make much more sense if they had originally figured in the lower part of a composition. Whatever the defects of the principal image, the border decoration is superb. However, no satisfactory explanation has been found for the six heads on the right. In the context of the Nativity, the likeliest contenders would be the Magi and the shepherds, but this is nothing more than conjecture.

Courtesy of Trinity College Library, Dublin

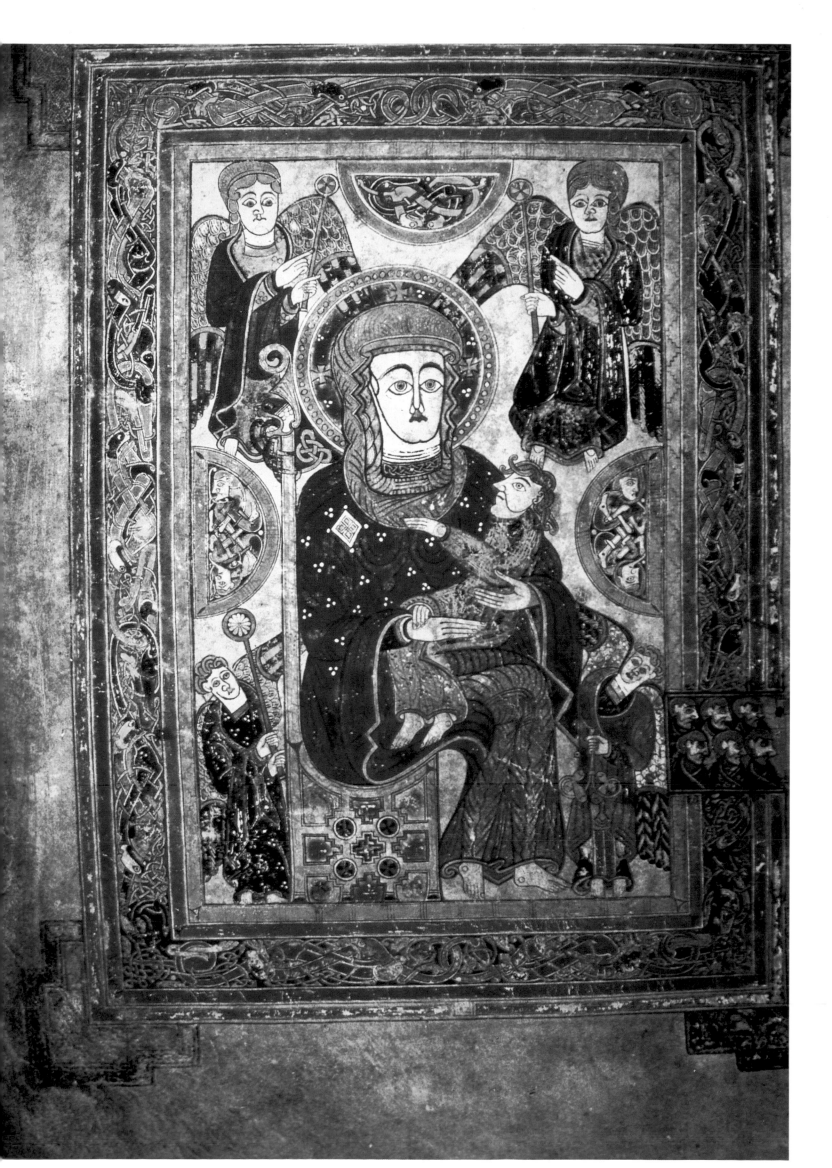

PLATE 23

PORTRAIT OF ST LUKE

MacDurnan Gospels, late ninth century

This Gospel book takes its name from Maelbrigte MacTornáin or MacDurnan, a distinguished cleric who was abbot of Armagh and, after 891, head of the Columban monasteries. Before his death 'at a happy old age' in 927, MacDurnan is said to have taught from the book and he may even have supervised its production. Certainly, there is no reason to doubt that the manuscript was produced in the scriptorium at Armagh and it is probable that the scribe was a pupil of Ferdomnach (d.846), who had worked on 'the Book of Armagh' earlier in the century. The Gospels did not remain in the country long after MacDurnan's death, as the book is known to have been presented by King Athelstan (925-40) to the library at Canterbury Cathedral. From there, it eventually passed to Lambeth Palace.

The MacDurnan Gospels represent the twilight of a great tradition. The volume is notable mainly for its large initials and its portraits of the Evangelists. The latter are generally pictured in ecclesiastical dress, holding a book and crozier, and are characterized by their long, elegant hands. There is decorative interlacing in the borders, but it lacks the intricacy and inventiveness of some of its predecessors.

Courtesy of Lambeth Palace Library, London

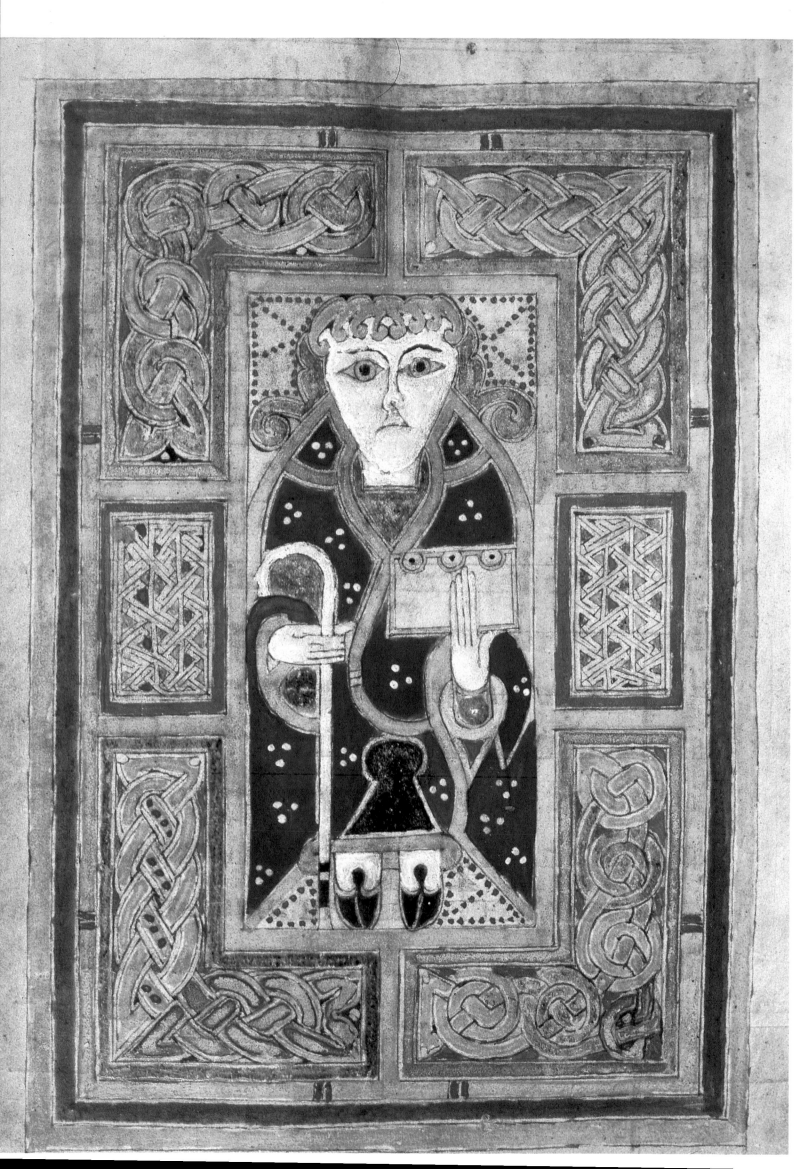

PLATE 24

THE CROSS OF THE SCRIPTURES

Clonmacnoise, Co. Offaly, early tenth century

The Irish practice of erecting decorative high crosses in monastic precincts dates from the seventh or eighth century. They may have been intended as a mark of consecrated ground, prior to the construction of a church, or as a form of protection for existing buildings. They also provided a focal point for some communal prayers.

The Cross of the Scriptures is the finest of the three crosses remaining at Clonmacnoise. A partial inscription suggests that it was set up by Abbot Colman in honour of King Flann (d.916), who was buried nearby. The carvings have weathered badly over the centuries and cannot now all be identified. However, the east face, shown here, includes a fine depiction of the Last Judgment within the main roundel. Christ the Judge is flanked by a trumpeting angel and a devil, who lead away the Elect and the Damned respectively. Above the circle, Moses is shown in prayer with Aaron and Hur, while the lowest of the three panels on the shaft represents Ciaran and Diarmuid planting the foundation post at Clonmacnoise. The other side features a Crucifixion and scenes from the Passion. There are many affinities between Celtic crosses and the early Gospel miniatures. Here, for example, the pose of Christ the Judge and the house-shaped summit of the shaft evoke memories of the 'Temptation of Christ' in the Book of Kells (q.v.).

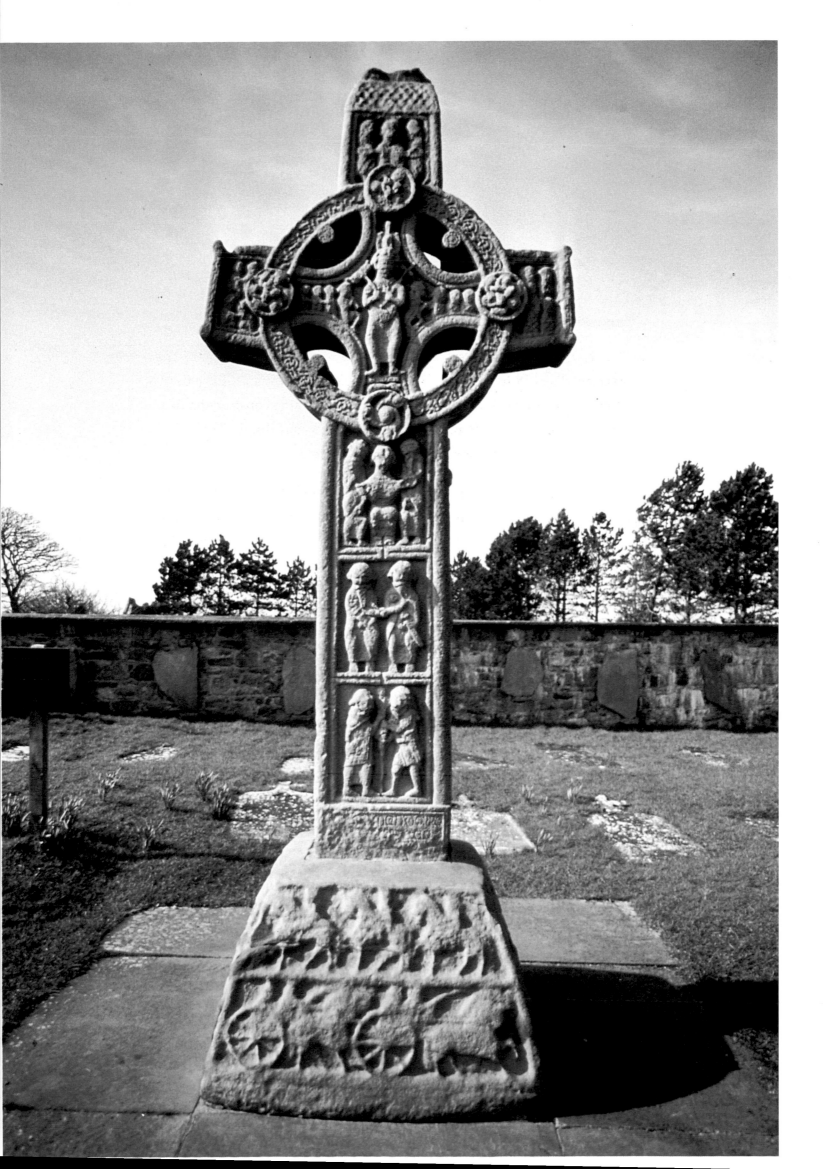

PLATE 25

CELTIC ORNAMENT

Knotwork and interlacings provided the artists of the Gospel books with the staple elements of their designs. The initial impetus is likely to have come from contemporary textiles and basketwork but, as so few artefacts from this era have survived, the precise extent of their influence is hard to determine. Some of the broader, intertwined patterns also suggest affinities with leather and strapwork.

Repeated knotwork patterns were used in the borders and on the carpet-pages of the earlier Gospels, although variations in colour were introduced to mask the continuity of the line and to avoid monotony. The Celts also loved to create motifs in the voids of their designs. Thus, the interwoven bands on 33 were arranged to form the crosses that were expected on a carpet-page.

Key patterns are more commonly associated with classical art, but the Celts also used them, generally employing a more diagonal format (e.g. 6 and 14). Note, too, the rudimentary swastika in 10. This was a traditional solar symbol in many cultures, although it was often used simply as an emblem of good luck. It features as such in the bosses on the Battersea Shield.

Encyclopedia of Ornament, *A Racinet, 1873*

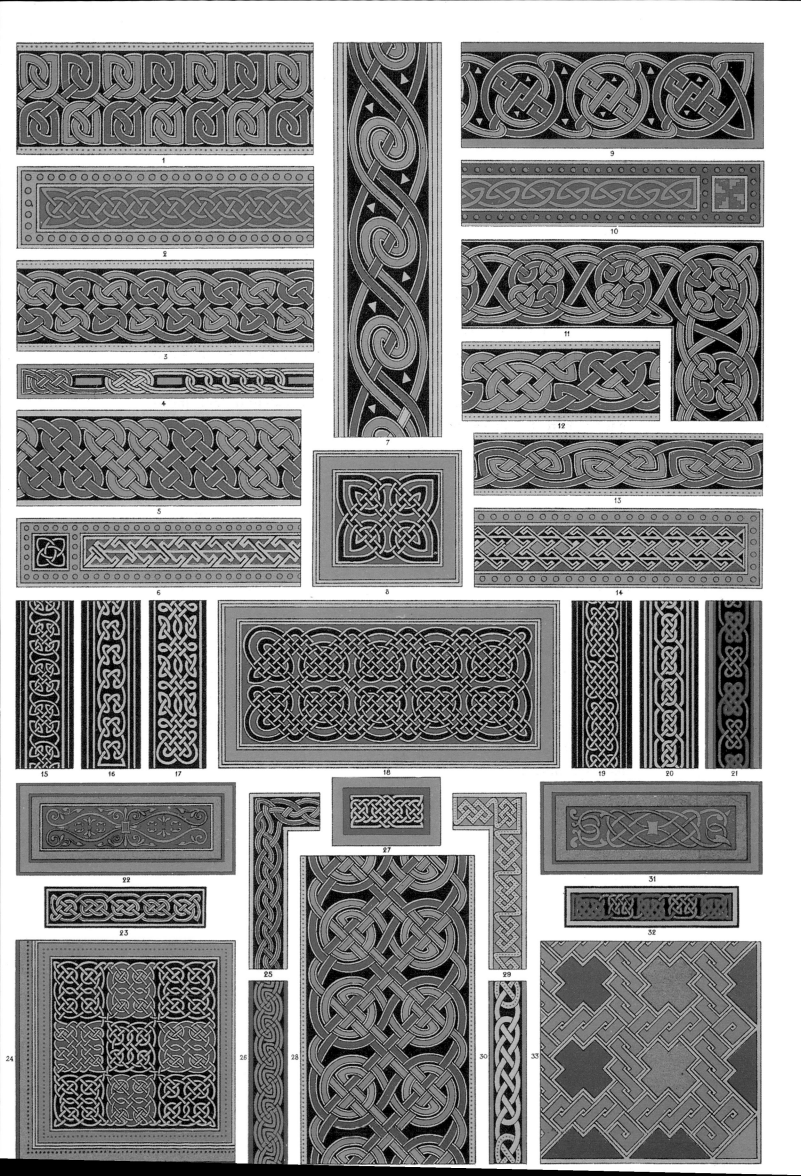

PLATE 26

CELTIC ORNAMENT

The zoomorphic interlacing that features so prominently in the early Gospels is one of the chief delights of Celtic art. This is due to the delicate balance between natural and abstract motifs. In 7, for example, the jaws of the beasts taper away into ornamental bands and encircle the flanks of their neighbour. Similarly, their legs stretch out like rubber tubes, the hind one winding its way round the animal's neck before metamorphosing back into a paw. Comparable transformations can be found in 1, 2, 4 and 5. These ingenious mutations are the distant ancestors of modern animated cartoons. The motif on 3 is meant to be read as a double-barrelled cross. Examples can be found on carpet-pages in both the Book of Durrow and the Book of Kells.

The Dictionary of Ornament, *A Racinet, 1885*

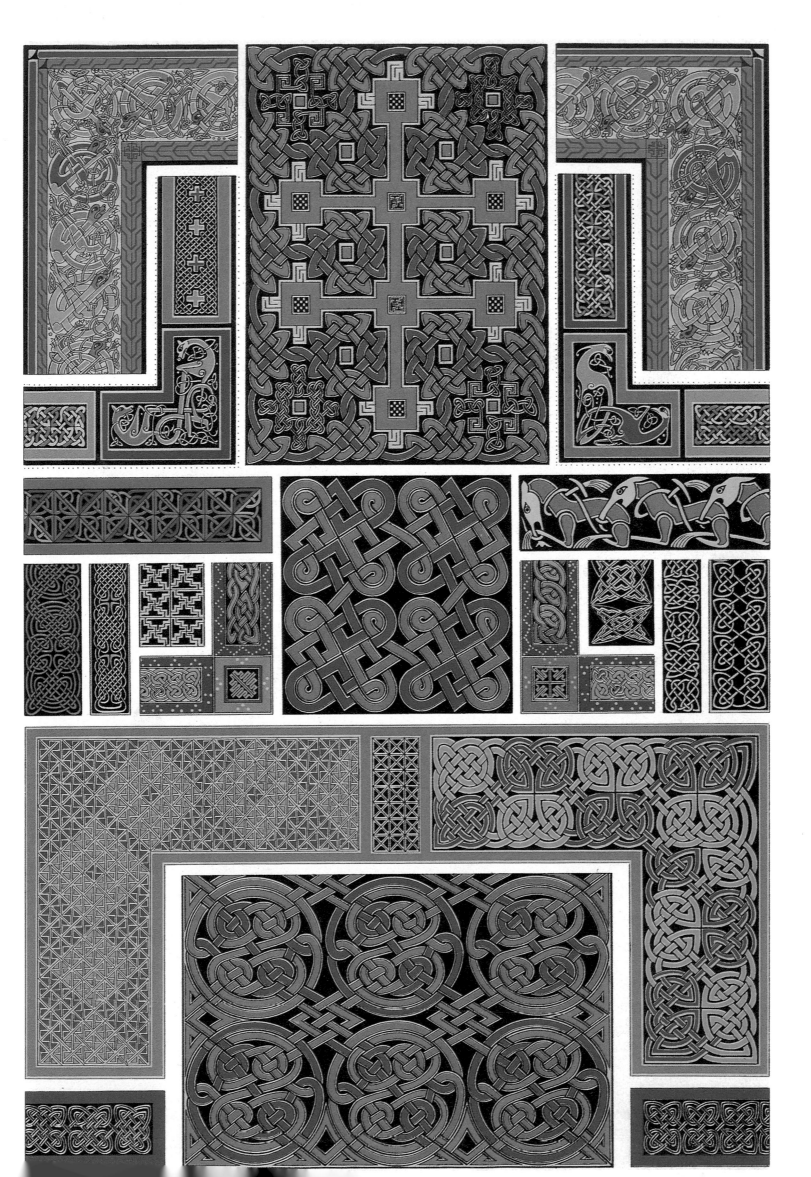

PICTURE CREDITS

ARCHIV FÜR KUNST UND GESCHICHTE/ERIC LESSING
pages 2, 8, Plates 6, 7

ANCIENT ART AND ARCHITECTURE COLLECTION
Plates 5, 16, 21

THE BRIDGEMAN ART LIBRARY, LONDON
Plates 1, 11, 15, 18, 22, 23 and Cover

THE BRITISH LIBRARY, LONDON
Plates 12, 13, 14

THE BRITISH MUSEUM, LONDON
Plate 8

E. T. ARCHIVE, LONDON
Plates 3, 4, 19

ANTHONY WEIR/FORTEAN PICTURE LIBRARY
Plate 24

THE GREEN STUDIO, DUBLIN
Plates 10, 17, 20

MARLBOROUGH PHOTOGRAPHIC LIBRARY
page 6, Plates 2, 9